the secret art of

Antonin Artaud

the secret art of

Antonin Artaud

Jacques Derrida & Paule Thévenin

translation and preface by Mary Ann Caws

The MIT Press · Cambridge, Massachusetts · London, England

Originally published by Schirmer/Mosel Verlag, Munich, 1986 © Schirmer/
Mosel, München and Jacques Derrida
Preface © 1998 Mary Ann Caws
This translation © 1998 Massachusetts Institute of Technology

The photographs of Antonin Artaud in this book were taken by Georges
Pastier in 1947.

This book was set in Stuyvesant and Giovanni by Graphic Composition, Inc.

Printed and bound in the United States of America.

Library of Congress Cataloging-in-Publication Data
Thévenin, Paule.
 [Antonin Artaud. English]
 The secret art of Antonin Artaud / Jacques Derrida and Paule Thévenin ;
translated by Mary Ann Caws.
 p. cm.
 Abridged translation of: Antonin Artaud. 1986. With new illustrations by
Georges Pastier.
 Thévenin's name appears first on the original edition.
 Includes bibliographical references.
 ISBN 0-262-04165-0 (hardcover : alk. paper)
 1. Artaud, Antonin, 1896–1948—Criticism and interpretation.
2. Portrait drawing, French. 3. Portrait drawing—20th century—France.
4. Drawing, French. 5. Drawing—20th century—France.
I. Derrida, Jacques. II. Title.
NC248.A72T4713 1998
741'.092—dc21 97-44637
 CIP

*E*ach time I happen to recall—nostalgically—the surrealist rebellion as expressed in its original purity and intransigence, it is the personality of Antonin Artaud that stands out in its dark magnificence, it is a certain intonation in his voice that injects specks of gold into his whispering voice. . . . Antonin Artaud: I do not have to account in his stead for what he has experienced nor for what he has suffered. . . . I know that Antonin Artaud *saw*, the way Rimbaud, as well as Novalis and Arnim before him, had spoken of *seeing*. It is of little consequence, ever since the publication of *Aurelia*, that what was *seen* this way does not coincide with what is *objectively visible*. The real tragedy is that the society to which we are less and less honored to belong persists in making it an inexpiable crime to have gone over to *the other side of the looking glass*. In the name of everything that is more than ever close to my heart, I cheer the return to freedom of Antonin Artaud in a world where freedom itself must be reinvented. Beyond all the mundane denials, I place all my faith in Antonin Artaud, that man of prodigies. I salute Antonin Artaud for his passionate, heroic negation of everything that causes us to be dead while alive.

André Breton, "A Tribute to Antonin Artaud," pp. 77–79, in *Free Rein* (*La Clé des champs*), trans. Michel Parmentier and Jacqueline d'Amboise (Lincoln: University of Nebraska Press, 1995)

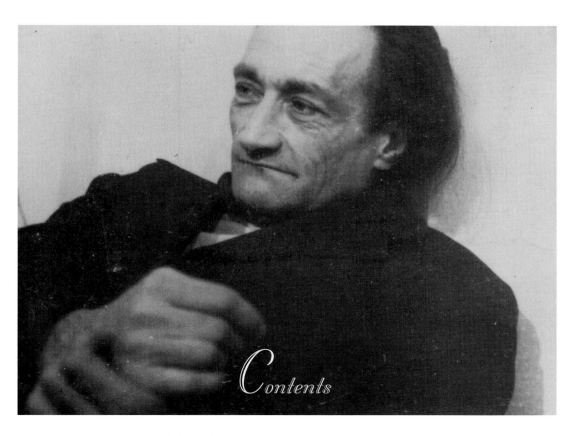

Contents

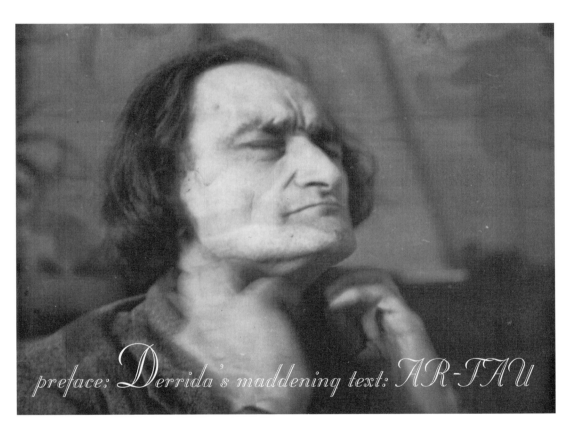

preface: *Derrida's maddening text: AR-TAU*

Mary Ann Caws

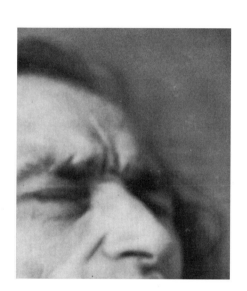

*O*nly the title of the original publication of Paule Thévenin and Jacques Derrida's commentary on Antonin Artaud's art is simple: *Antonin Artaud: dessins et portraits.* Everything else is of a complication you can really sink your mind into. Derrida's text, "Forcener le subjectile"—an expression that forces, incarcerates, and maddens in a touch of unfathomable genius—deals fathoms deep with what *underlies* a text like that of Artaud himself, so visually, verbally, heroically mad. It sets out to further a frenzy, to unsense completely, to set things askew—forever.

The language is already layers deep in strain: since this volume was to appear first in Germany, and originally only there (Munich: Schirmer/ Mosel Verlag, 1986) and not in France, Derrida's French text, prepared for German readers, addresses, in footnotes and asides, the difference between the Latinity of French and the anti-Latin nature of German: "How will they translate this?" "German has no way of saying . . ." "You are reading in German here. . . ." As the French version leaves those strains in, so does the Englished version, deliberately: the strain contributes to the depth. Derrida's French struggles with Artaud's peculiar language, as with the predicted German reception to his struggle; just so, the translator into English struggles with both, against and along with the otherness, I might say the foreignness, of Artaud himself.

To be sure, his mother tongue is not mine, but he did not want it to be his either, lashing out as he did against anything reeking of the "father-mother." Just as the strangeness, the foreignness of Artaud's language, even before Rodez, exacerbates the serious gap between original and translation(s), it enables Derrida to find, to force and frenzy and *unsense* the underlying support of canvas, paper, text: this *subjectile* of which the initial passage speaks at such length and in such difficult depth. It is marvelously and strictly unbearable.

Derrida warns against anyone trying to speak *like* Artaud, in order to "understand" him. His own speaking here is addressed toward what

underlies both language and art like a support, at once the subject-he and the subject-she: this so-called "subjectile" which is his subject, and which is not to be translated. Which will, says Derrida, never cross the border of French. Which is both male and female, and at the same time serves as birthing table for text and canvas, as the mater/matrix/pater, whose double-sensed *couches* signal at once the labor of birthing, and the layers and layers underpinning what we hear and see and call by the name of art. The subjectile is in *couches*, literally giving birth, and in layers, prehistoric, historic, and posthistoric. If it is having birth pangs, so is this text, so long to come to English. The subjectile is multiply contrarian: matrix and fiend, belying, birthing, and betraying. The text of Derrida is no less frenzied than that of Artaud, inscribed in the surface and the undersurface, the subjectile of his drawings and portraits cast as spells. The best the translator can hope for is not to break the spell.

Under this spell, any address or skill risks a sudden turn into what Artaud calls "maladresse," a very serious awkwardness, seriously taken and received—as in God's own mistakenness: "la maladresse sexuelle de dieu." The rather more straightforward text of Paule Thévenin describing the history of Artaud's art and drawing up the list of its naming, and the text of Derrida, brilliantly inscribed in the name of this madness outpoured, originally made up this most justly maddening *catalogue irraisonné* for an exhibition of frenzy. The project calls for a rendering that can espouse AR-TAU's willed self-projection past his name and language, past any mother tongue at all.

This book should be read, says Artaud of his writing, like a musical score. "We won't be describing any paintings," says Derrida. And indeed, this text will read like a drama without words, like a descriptionless meditation on the birth of essences that call for no description. The narrative has no plot outline, just a nonreferential play of meditation refusing any submission to the customary outlaying of events and pictures you can

prendre, comprendre. You can take Derrida up, but you cannot take him. He plays with the letter, rolling Artaud's letters with him, through him, like thunder: TR, BR, RA, making incisions like Artaud's own flaming of faces and texts. Here the match was lit, here is the hole, here the tear. The text is, like the portraits and drawings, magnificently *terrible,* in the sense of Gerard Manley Hopkins's "Terrible Sonnets"—truly terrifying.

Among all the pictures—pictograms—that Artaud *committed,* yes that is the best word for it, *La Machine de l'être, ou Dessin à regarder de travi-ole* (The Machine of Being, or the Drawing to Be Looked at Sideways) sticks in my mind. It is at the center of the strain. Because of the figures, human and half-human, off balance, and the tablets of writing against the ochre, green, and eggshell backdrop; because of the circles there, filled with their own rumblings and rollings: "roule dans la rotule . . ."; and because of the intense discomfort of the whole thing.

"Mais ça n'ira pas encore," reads one of Artaud's tablets, and we know it to be true. This won't do yet, not this pictogram of suffering, not this French rendering of an other for the German viewers and readers, not this English rendering for Anglophones, not these frenzied and frenzying answers to Artaud's texts. The two words in the lower right corner of the drawing read: "dessous droit"—right above his signature, itself under-lined and neat. No matter how straight up—*droit*—we might have wanted to hold ourselves in the face of these extraordinary testimonies to vitality as to madness, we will have the feeling of being *dessous:* under this birth-ing table, under and subject to the subjectile that itself refuses to be domi-nated by the writing process. *Forcené/For-sené:* unsensed by genius, but not senseless. For unsense has in it the peculiar echo of an *incense* . . . some-thing is consecrated here. Sense is not simply lost, it is gravely undone. There is a serious difference.

Of his oddly lovely labyrinth of an *essay,* "Forcener le subjectile" with its central discussion of the subjectile incarcerated in his commentary

on the pictogram to be looked at sideways, Jacques Derrida asks: "Am I even writing in French?"—He is perhaps asking it of us also. To his forcing—*for-sens*—and beyond-sense sense of languages that maddens what it touches and who hears it, I have given the only response I could: looking at the pictograms sideways and straight on, before translating the entire text; then, waiting for the text to grow in me; and finally, retranslating it two years later, and again three years beyond that, to give it these layers or *couches* of response, its labor pains of English birth.

Paule Thévenin devoted her life to the edition of the works of Antonin Artaud, whose close friend she was. It was on the walls of her apartment that Jacques Derrida saw those paintings and drawings, and it was she who suggested he write his essay.

It is deeply regrettable that the Artaud estate did not allow us to use in this volume the reproductions of the very paintings and drawings that were at the origin of these texts. (Many of them can be found in two other publications: Mary Ann Caws, *Antonin Artaud: Works on Paper* [Museum of Modern Art, 1996] and *The Surrealist Look: An Erotics of Encounter* [MIT Press, 1997].) It is also deeply ironic, given Jacques Derrida's work on the absence of origin. We have chosen, in their stead, the extraordinary images of Artaud by Georges Pastier that capture, more than any others, his tortured genius.

Mary Ann Caws
New York, November 1996

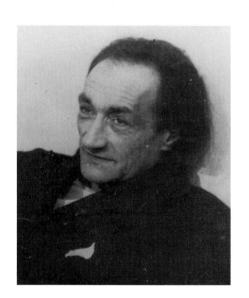

the secret art of

Antonin Artaud

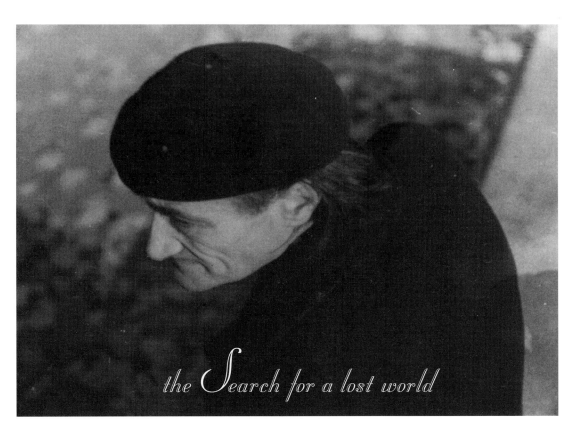

the Search for a lost world

Paule Thévenin

\mathcal{A}ntonin Artaud used to say he had really learned to draw and paint during his stay in Dr. Dardel's establishment, Le Chanet, near Neuchâtel in Switzerland. He arrived in the fall of 1918 and left in the beginning of 1920.

Nevertheless two of his first preserved graphic works were dated 1915. In both cases the date was given—although far later—by his sister, Madame Malausséna. One is a tiny gouache, the size of a postcard, which was part of an exhibition in 1977 at the National Book League, in London, and which is said to represent a landscape at Châtelard, Savoie. We can suppose it to have been dated according to youthful memories of various family vacations in the mountains, but such memories are often slightly hazy. The second is a self-portrait reproduced in December 1959 in *La Tour de feu* where it is represented as a charcoal done in 1915 in Marseilles. The line is very firm, far more confident than that of the charcoals done in 1919 at Le Chanet. Besides, the treatment of the hair reminds us of Artaud's haircut as it appears in pictures taken between 1918 and 1921. And the high shirt collar is the one he used to wear in those years. Madame Malausséna no doubt had her reasons for dating this self-portrait from the time in Marseilles, but I would rather date it after his return from Le Chanet in the beginning of 1920.

Two signed works[1] among those that have reached us, and which Artaud must have thought of as finished, date from the year he spent in Switzerland: the charcoal of a young patient in the care of Dr. Dardel[2] and a still life in oils, three apples in a dish, with Cézanne's shades of blue and rather beautiful. Antonin Artaud had given it to a girl his age, Rette Elmer, who had come to Le Chanet in July and August 1919 to be with her father, also a patient in the clinic. They had become friends, and that friendship lasted well into her marriage with René Lamy in 1920. Although after 1925 their relationship became less intimate, by dint of circumstances, Antonin Artaud had sufficiently impressed her for her to

have kept this little oil hanging all her life on one of her walls, and to have preserved a few drawings and gouaches from the Swiss period. These works, all small in size, show sensitivity, taste, and a certain feeling for color. They show also that Artaud had always known how to look at the most contemporary painting, from the impressionists to the fauves, that he must have known the symbolists very well, and that he had been deeply moved by the anxious landscapes of Edvard Munch.

1920: he arrived in Paris after a brief stay in Marseilles. We know that his parents had entrusted him to Dr. Edouard Toulouse, the doctor in charge of the asylum at Villejuif, whose ambition it was to isolate and study the mechanisms of genius, and who had for that purpose chosen a number of the highly intelligent persons of his time, from Zola to Poincaré, including Mallarmé, Loti, Daudet, and many others. So there was nothing surprising about his thinking Antonin Artaud a choice recruit. This probably explains why Antonin Artaud was first housed in the home of the mental specialist and his wife Jeanne, which was not a current practice at the time. After that he was to live alone, but in Villejuif itself and very near their home. The fortunate consequence of these particular circumstances was that many of his drawings of the years 1920–1921 were kept by Jeanne Toulouse. Some of them, which she turned over to Madame Malausséna, were shown in the London exhibition.

Antonin Artaud's interest in paintings, drawings, and engravings is also obvious in his first years in Paris, the years of his beginnings in the theater. In the journal founded in 1912 by Dr. Toulouse, *Demain*, of which he becomes the coeditor with Gonzague Truc, and whose monthly appearance becomes increasingly problematic until it disappears in 1922, and in *L'Oeuvre*, the theater newsletter directed by Lugné-Poe, an authentic art lover who had hired him in April of 1920, he publishes several reviews of Salons and articles on painting that reveal his tastes and his conception of visual work: "Why do you paint? You paint to say something and not to verify theories. And what you have to say can only be

said with the forms surrounding us. When we say something, they are what we say."[3] But these forms through which the painter speaks to us have no meaning unless they have been thought before, and correspond to what he just discovered and was trying to reveal to us. The work is not a goal to be attained, but a means. So what counts more than anything else is the expression it transmits, either that of a certain maturity of an art or the secret vital palpitation of a model. "The subject matters little, like the object. What matters is the expression, not the expression of the object, but of a certain ideal of the artist, of a certain sum of humanity expressed in colors and lines."[4]

Any inelegance or clumsiness are of no account, if the deep discourse of the artist has come through the canvas or the paper in some way. The work is a movement whose origin is one intense absolute moment: the encounter between whatever of the model (even if it is a concept, an abstraction) passes into the eye and the head of the artist, and this impulse to express it which will move his hand. And this movement continues far past the moment when the hand that transmitted it has ceased moving. It makes the canvas or the paper tremble, vibrate, before this eye of the other watching, and years or even centuries afterward can continue to play on the nervous impulse that produced the gesture. Of all that Antonin Artaud is already persuaded in 1920–1921. And it is surely not by chance that, speaking of painting, he evokes the artist's diction: "The drawing passes over to the second level. I don't mean the direction of the line, but its execution. When the artist has thought out his work with a certain profile, nothing of what he had to say being absolute, when the fullness of diction has answered the fullness of expression, what does a weak or faltering stroke matter?"[5] Perhaps the voice, more than the gesture or the gaze, acts as if hypnotically upon the nervous temperament, producing almost magical effects. And the diction of the artist (that is to say, his way of expressing himself) must be just as active and persuasive, according to Artaud, for through it will pass this *profound truth*, this truth

imagined, by a formidable effort, for himself and his word. Above all, it acts as a relay between different sensitivities in their interactions. That is why the intensity of the expression is primordial: "It is perfectly clear, in the last analysis, that a painting takes its value from the expression. By the expression, I don't just mean a certain way of laughing or weeping, but the profound truth of art."[6] By its means the interpreter will make himself understood, will make us understand what he has to say to us, only possible if he manages to disturb the organism in its most intimate ramifications. The importance that Antonin Artaud gives to expression in painting is comparable to that of representation in *Le Théâtre de la cruauté* (The Theater of Cruelty), and what he will then write about scenic language could apply to painting; the word *spectacle* would be replaced by the word *picture:* "This is to say that poetry comes to inhabit exterior objects and that from their assembly and their choice it draws strange consonances and images, everything in the spectacle aiming at expression by physical means *involving* the mind as well as the senses."[7] This very necessity of expression leads the artist to be only slightly preoccupied with trying to reproduce apparent reality—and, after all, what is this reality anyway, and does it even exist? It is scarcely by the faithful reconstitution of forms that he can bring forth from the canvas or the paper this vision that imposed itself on him, that his genius alone permitted him to grasp, and that he can pass on to us only at the price of necessary deformations: "Why does the painter deform? Because the model in itself is nothing, but the result is everything the model implies about humanity, everything that, through the model, can be said of life stormy and frightened, anguished or becalmed."[8]

Reading these lines, we can't help thinking that twenty-five years later, at the end of his life, Antonin Artaud will make of the *human face* the battlefield for a frenzied struggle between the forces of life and death. But, in 1921–1922, drawing is at most for him just a possibility. He has acquired a certain skill. His glance is rapid and his hand adroit. He has

been accepted in the Atelier company, and Dullin, who knows how to use the talents of those who work with him, is putting to some use his gifts for drawing. Writing in February-March 1922 to Yvonne Gilles, a young painter whom he met in 1917 at Divonne-les-Bains, a thermal station where she went at the same time he did, he tells her he has busied himself with the decors and has drawn a Harlequin for the cover of the company's program. For the first spectacles presented by the Atelier in March and April 1922, the name of the stage designer is not mentioned, just that of the costume designer. Antonin Artaud had designed the costumes for *The Olives* of Lope de Rueda and *The Hostelry* of Francesco de Castro, and he may also have designed the decors of these two one-act plays, which were supposed to be free of anecdote, according to the aesthetic preferences of Dullin. In June, he will again design the costumes for Calderón's *Life Is a Dream* [*La vida es sueño*], the decorative panels done by the painter André Fraye. But he must have felt his talents exploited without receiving proper compensation when, at the end of July 1922, he declares to Génica Athanasiou that he will no longer design costumes for anyone but himself. Few traces remain of the work he did that year: the design of a costume for *The Olives*, a portrait of Génica in the role of Estrelle in *Life Is a Dream*, a few photographs of this spectacle in a magazine, and the Harlequin. During the summer, he designs costumes for Jacinto Grau's *Count Alarcos*. This play, in a translation by Francis de Miomandre, will be announced in the repertory of the Atelier for the 1922–1923 seasons,[9] and Antonin Artaud must have been secretly hoping that the staging, the decors, and the costumes would be entrusted to him. None of these drawings has come down to us. The only extant drawing from that summer is that of a costume for a ballet on the theme of fire, conceived for Génica.

During the next theatrical season, he will do nothing of that sort either for Dullin, after leaving him, nor for any of the designers with whom he will work on the scenes of the Champs-Elysées, Pitoëff in particular. Two self-caricaturing portraits drawn in letters to Génica mark the

time he spent in Pitoëff's company. Also conserved, done on separate sheets and slipped into the envelope of a letter sent November 12, 1923, to Génica, are a portrait of the latter and another self-portrait. A small picture after Picasso's *Two Friends,* dating from the same period, has also come down to us.

However, that year Antonin Artaud had started on oils again. Probably urged on by Yvonne Gilles, he undertook in May to do her portrait,[10] which had already been projected in September 1921, and one of her father. He was apparently dissatisfied with the first results: "The two portraits that I started are unworthy stuff,"[11] he writes to Génica on May 6, 1923, grumbling about hauling his canvases and boxes of paints to Boulogne. He must not have worked very hard, because, in November, when the portrait of the girl was still not finished, he proposes to her to come pose in his hotel room, on avenue Montaigne.[12] There is a good chance that he never finished either one or the other and that he destroyed these sketches.

He seems after that not to have drawn or painted very much. Two architectural sketches illustrate his response to the survey on the "Evolution of the Stage Set," which appeared in *Comoedia* on April 19, 1924. They are both attributed to him, and destined for "*La Place de l'amour* [The Place of Love], a mental drama inspired by Marcel Schwob."[13] But André Masson claims to have done them and says he drew them according to Antonin Artaud's indications, for him to use them as he would like. André Masson's memory is excellent and he has never varied in this affirmation. You can see here a first sign of Antonin Artaud's disaffection from this mode of expression; he was certainly capable of drawing these schemas himself, and we can imagine that those he gave as models to his friend must not have been so different. However, he preferred for their final form the touch of the painter rather than his own.

One self-portrait, which must date from the years 1924–1926, was reproduced as the frontispiece of a story by Marcel Béalu: "La Bouche

ouverte" (The Open Mouth), of 1952. This drawing in pencil, given to Marcel Béalu by Max Jacob toward 1938, was done in Max Jacob's room on some table, one day when Artaud had come to see him. Max Jacob's correspondence tells us they saw each other often in October 1924,[14] and the expression of the face in this self-portrait is very close to the expression caught in one of the photographs Man Ray took of him in 1926: a fierce look, his lips closed tightly upon some untellable, unguessable torment.

The graphic manifestations of Antonin Artaud will become progressively more rare. In 1927, writing to Germaine Dulac about the stage sets planned by the latter for *La Coquille et le clergyman* (The Seashell and the Clergyman), he makes clear for her, in a sketch, how he sees the ballroom with its platform and the kind of doors he would like for it.[15] A "bad drawing" was included in a letter written on September 23, 1932, to André Rolland de Renéville.[16] A lost drawing. I had in my hands, about thirty-five years ago, some notes taken in 1933 by Antonin Artaud inspired by the *Dictionnaire de la Bible,* by Vigoroux, at the time when he was gathering the documentation indispensable to him for *Héliogabale ou L'Anarchiste couronné* (Heliogabalus, or The Anarchist Crowned); he had added three pen drawings reproducing some illustrations of the work he had consulted.[17] The manuscript and the drawings must now be dormant at some collector's.

Finally, in 1935, on the back of two manuscript pages of the *Cenci,* he draws three schemas of the sets he would have wanted for his play. Just as he had done ten years earlier with André Masson, this was doubtless to suggest to Balthus the scenic architecture he had in mind.

So Antonin Artaud almost completely stops drawing toward 1924. At that time he frequents the rue Blomet where André Masson had set up his studio, with Miró, Dubuffet, and Malkine as neighbors. In September 1924, his correspondence with Jacques Rivière, which deals with the

ontological impossibility of his producing a work and of bringing forth his thought, is published in *La Nouvelle Revue française*. André Breton is quick to appreciate the importance of these few pages, whose inflammatory violence could not have left him insensible. Their encounter has a logical, inevitable cast to it; it seems to be part of the normal order of things that, shortly thereafter, Antonin Artaud should have committed himself unreservedly to the surrealist movement. Surrounded by young men full of talent, graphic expression being for many of them far more of a necessity than for him, it must not have been entirely coincidental that he gave it up. Believing André Masson to be "the greatest painter in the world,"[18] could he resign himself to appearing as just a gifted amateur? Certainly not. And all the less since he experiences the devouring need to pursue the work of elucidation started by the correspondence with Jacques Rivière. From then on, the suppleness and subtlety of writing open for him a more appropriate domain in which he becomes particularly fecund. In less than two years he writes *L'Ombilic des limbes* (The Umbilicus of Limbo), *Le Pèse-Nerfs* (The Nerve-Weigher), and those prose pieces with their language at once precise and flamboyant, those iridescent poetic objects of *L'Art et la mort* (Art and Death). But painting remains a presence in the texts of these years; at least three are written under the inspiration of André Masson's work, admittedly or not. And doesn't "L'Automate personnel" (The Personal Automaton), in *L'Art et la mort*, take as its point of departure a portrait that Jean de Bosschère had just recently done of him, with which he associates "the strength of a fixated dream, as hard as an insect's shell and full of legs darting out in all directions of the sky"?[19]

From the end of 1926, after these two years of intense life in which he marked surrealism with his stamp—with such an ardor, such a fury that André Breton himself was shaken by it and feared seeing the movement exhaust itself in "a certain paroxysm"[20]—Antonin Artaud again turns toward the theater, but this time as an *animateur* and designer: this marks the creation of the Théâtre Alfred Jarry.

For him, the theater as it is seen in the West is denatured and moribund. He must restore this "true reality"[21] that it has lost, letting it "find again this character of a unique, unheard-of thing," the integrity "that certain written or painted ideas have retained."[22] Writing, painting, music, theater are so many diverse means of bringing forth what is buried and shadowed in our own depths, bringing it to light, trying to render it perceptible. Theater, able to utilize different media, shows in addition this essential particularity of not being able to do without the public, this multiplied body that the public is, and having to act upon it by the intermediary of the actor's body. Aiming to be a "magical operation,"[23] the theater can only be a "total spectacle,"[24] and for that it must have "that total freedom which exists in music, poetry, or painting, and from which it has been until now curiously estranged."[25] Thus, from 1926, the date on which his attempt to establish an "integral spectacle"[26] leads him to a theoretical reflection on the theater, marked by manifestos, until May 1935 when he manages to stage *Les Cenci*, Antonin Artaud will never cease to take account of painting, either painting in itself or taken as an ideal model, or painting in the form of visual representation summoned by the theater which intrinsically cannot do without images. One of the recognized objectives of the Théâtre Alfred Jarry is to "vivify a certain number of images, evident, palpable, unsullied with an eternal disillusion, . . . to succeed in showing everything so far obscure in the mind, buried, unrevealed, in a sort of real material projection, . . . bringing forth for all to see a few tableaux, undeniable and indestructible images that will speak directly to the mind."[27] Once again, everything he says could be said not of common illustration or banal imagery, but of all true painting. And it is not surprising that it is also present in what Antonin Artaud thinks, imagines, conceives. To neglect this fact would be to deny the importance of color and its symbolics in *Héliogabale ou L'Anarchiste couronné*. It would be to forget that a visit to the Louvre, in September 1931, acted as a trigger: looking at *Lot and His Daughters* of Lucas van Leyden, Antonin

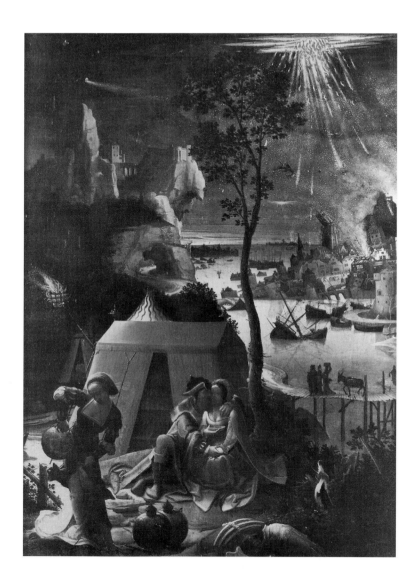

Lucas van Leyden, *Lot and His Daughters,* 1609. Musée du Louvre, Paris. Photo Giraudon/Art Resource, New York.

Artaud is suddenly struck by the profound resemblances that exist between the "staging" of the painter, such as it is presented on this canvas, and the gestural system of the Balinese dancers who appeared at the Colonial Exposition. The analogy seems so strong and evident to him that he will make it the theme of a lecture, first entitled "Peinture," which will become "Le Théâtre et la métaphysique." And it is the only one of the texts making up *Le Théâtre et son double* with references to the language of art.

Of the representations of the Balinese theater which are for him even more than a revelation, the model of everything the real theater should be, he says that the actors "with their geometrical robes seem animated hieroglyphs,"[28] that their spectacle embodies "the sense of a new physical language based on signs,"[29] that they give us a "marvelous composed of pure scenic images,"[30] that they know how to convey in sound "colorful allusions to natural impressions."[31]

For the gestures of an actor are so many ephemeral arabesques drawn with his body, the actors together constructing a sort of moving and colorful graphism akin to painting, having the stage for its frame. Everything must concur in this new language the theater requires, "this language composed of signs, gestures, and attitudes, with an ideographic value,"[32] where the face contains for the designer what it does for the painter, its innumerable expressions becoming so many eloquent signs, and where, just as if it were a question of conceiving a painting, "the ten thousand and one expressions of the face, considered as masks, can be labeled and catalogued so that they can participate directly and symbolically in this concrete language of the stage."[33] So it is natural that Antonin Artaud as he reflects on the theater should constantly allude to painting, wishing that the images created upon a stage could strike us in the same way as "the nightmares of Flemish painting,"[34] and seeing in certain canvases, like the fantastic *Dulle Griet* of Breughel, for example, prodigious

and silent stage settings: "theater is swarming through it."[35] But to the extent that theater, beyond signs, lines, and color, places at his disposition movement and words with all the infinite modulations of the voice, of music and its rhythmical scansions, being far more complete for him than any pictorial representation it meets all the requirements of the visual arts. Which probably explains his apparent renunciation of drawing. Only apparent, because he never ceased proposing for the spectator those various corporeal interweavings, those wavy motions of forms and bright shapes of the fugitive and mobile tableaux which no sooner appear than they disappear in the stage air, and whose fugacity and fragility compose their value. And it must be said that it is after the relative respite of the Mexican attempt—that year spent outside of Europe, when he tried desperately to participate in the cultural, social, and political life of a country, determined at the same time to find once more its primitive spirit ("the one that cannot see what is, because nothing exists in reality, but which, by the brush or pen, reproduces what it supposes, and what it supposes is always in the measure of its limitless imagination"),[36] the primitive spirit that created the divine forms buried in the museums or the archaeological sites, whose revival he thought he had discovered in certain young contemporary Mexican artists (in particular the painter María Izquierdo whose gouaches he will bring back to Paris, organizing an exhibition of them in a gallery on the boulevard Montparnasse), after that sort of truce and long after he gives up the dream of realizing a total theater— that again in 1937 there will appear from his hand, upon a white page, graphic signs.

First placed there to signal a particular passage, or as an informative supplement, these signs will take on very rapidly an autonomous function, especially in the letters sent from Ireland, where Antonin Artaud, who has shown his wish to lose his identity completely as a writer, comes, almost completely destitute, to meet his tragic destiny. Very often, during

those months of August and September 1937, his signature is accompanied by a triple sign: the symbol of the feminine sex—which is also that of the planet Venus—augmented with an oblique stroke at its summit, on top of two triangles with the point upward, an almost magical sign, as are for him the two weapons he has procured: a little Toledo sword that a black sorcerer is supposed to have given him in Havana, and a knotted cane that he says he got from a Savoyard sorcerer, thinking it to be the very cane of Saint Patrick, the patron saint of the Irish, a cane with which he will harangue the passersby in Dublin in a language that he doesn't know very well. Also from Dublin will come those first missives, conjuratory and protective or offensive and vindictive, that he calls "spells."

Writing no longer has as its sole function that of transmitting a message or a thought; rather, it must act by itself and physically. Everything is studied, calculated so as to strike the eye, and through it the sensitivity, of the person for whom the spell is destined: the disposition of the lines on the page, the very careful calligraphy, the variations in size or height of the letters, the frequent use of capitals, the way the words are underlined. Lines are sometimes displaced and signs are added. At times, especially when the spell is an aggressive one, the paper is intentionally spotted in places, and, in others, burned and perforated with a lit cigarette.

We know the frightful denouement of the trip to Ireland: the internment at Le Havre, the last day of September 1937, an internment of nine years. In May 1939, at Ville-Evrard, Antonin Artaud again starts to fabricate his spells. These are much more elaborately drawn and particularly more colorful: mainly the violet, the red, and the yellow ochre spread out in wide swaths on the paper that will be devoured subsequently here and there by the lit end of a cigarette or the tip of a match flame: "And the figures that I was making were spells—that I burned with a match after having so meticulously drawn them."[37] Something was produced, halfway

between a drawing and an object, and can function as a talisman, a gri-gri against any traps set, or, on the contrary, as an evil curse. And all this concurred in its creation: writing, first of all, but writing mistreated, perforated, consumed, both the drawing and the color, and even the support itself, the sheet of paper against which the hand of Antonin Artaud set itself with such fury. "Included here is a bad drawing," he wrote on September 23, 1932, to André Rolland de Renéville, "where what is called the subjectile betrayed me,"[38] and a bit of the letter was torn off, doubtless to make the trace of this treason disappear. But, at Ville-Evrard, he does not permit the subjectile to betray him, he treats it as an adverse body, attacking it and placing it utterly at his mercy:

The figures on the inert page said nothing under my hand. They offered themselves to me like millstones which would not inspire the drawing, and which I could probe, cut, scrape, file, sew, unsew, shred, slash, and stitch without the subjectile ever complaining through father or through mother.[39]

That these spells have a strong emotional charge is undeniable: they responded to a necessity, to the imperious need of showing—though death is felt as possible, and even imminent—one's own existence, that one is not completely dead. It is not without interest to note that Antonin Artaud will declare himself subsequently to have died at Ville-Evrard in August 1939, thus shortly after the casting of the spells—and there is no doubt that one of their goals is to protect him against disappearance, to affirm his combative will:

The goal of all these figures drawn and colored was an exorcism of malediction, a bodily vituperation against the obligations of spatial form, of perspective, of measure, of balance, of dimension, and, through this vindictive vituperation, a condemnation of the psychic world encrusted like a louse on the physical world that it incubuses or succubuses while claiming to have formed it.[40]

These strange objects, Antonin Artaud lets it be understood, these kinds of amulet also have a curative function, counteracting an unhealthy power that the psychic wields over the physical. Like their offensive powers, their defensive powers are evident, suffused with the energy of their fabrication, the violence of their intentions, their devastating effects. Plunged into the world of magic spells, we can scarcely escape these flames which, from all sides, lick at the tranquil and comfortable space where we would like to remain. We can scarcely look at these objects without being contaminated by their vehemence, or then we don't understand anything; we can only see an extraordinary theatricality rising from these pages, palpitating under all the tortures undergone, underlaid by a contestatory will which, even as it argues with them, is based on forms, signs, colors, and through that very fact sees to it that these spells are real visual constructions:

I mean that in ignoring drawing as well as nature I had resolved to leave behind those forms, lines, strokes, shadows, colors, and aspects which, just as in modern painting, neither represented anything nor demanded to be united by the consistency of any visual or material law, but rather created, as if above the paper, a kind of counterfigure perpetually protesting against the law of the created object.[41]

It could even be said that the paroxysm of spell-casting in May 1939 announces the blaze of texts written by Antonin Artaud after his departure from Rodez, those explosive, percussive texts with their ravaging humor, parallel to the stupefying landscapes of faces and bodies that compose his last drawings.

Then he seems no longer to draw. A few fugitive reapparitions of signs in his letters toward June-July of 1941. Subsequently, he is transferred to Rodez at the beginning of 1943. In the spring, Frédéric Delanglade, a Marseillais painter with surrealist tendencies and a war refugee, comes to take shelter in Rodez near his friend Gaston Ferdière. There has

been a great deal of exaggeration, both spoken and written, about how instrumental he was in Antonin Artaud's starting to draw again, suggesting that he persuaded him to do so and furnished him with the means. Antonin Artaud himself contributed to that legend in stressing the intervention of Delanglade in this domain, but that was in a letter to the psychiatrist on whom his fate depended, and the painter was an intimate friend of this psychiatrist. Without denying that Delanglade could have given him pencils, charcoal, paper, we should still understand that he would not have drawn anything had he not felt the need for it. What we may suppose is that seeing a painter confronting his work, and present to evaluate the results daily—whatever his or Antonin Artaud's own intimate judgment might have been about it—posed again, specifically and concretely, the question of drawing and of painting.[42] What is sure is that at the beginning of February 1944, thus about a year after Delanglade's arrival at Rodez, he had done a few drawings and shown his intention of starting with gouaches again:

I am very glad that my drawings pleased you, because I have not drawn for twenty years now, and I have never tried any imaginative drawing; scarcely fifteen days ago I didn't believe myself capable of expressing my ideas by those means. And it is at the pressing instigation of F. Delanglade, who is a true and very deep friend, that I tried it. / I shall make you a gouache since you like this medium. If I was silent for an instant when you spoke to me about it, it is not all that I didn't want to satisfy you, on the contrary. It's that not having touched a brush for years, I wondered very simply if I could succeed in something that would captivate you too.[43]

Antonin Artaud had brought back from Rodez four charcoal drawings (one of them has disappeared), rather small in dimension like his youthful drawings (very often executed in charcoal), which must date

from this period. In any case, we find there some of the symbols also found in a letter of October 13, 1943, to Pierre Laval,[44] such as the cross and the sign of infinity. As for his taking up gouache again, that was, according to all appearances, a project with no sequel.

It is only at the beginning of 1945 that he will start really drawing again, undertaking those great colorful compositions for which he uses in general a very large format. If we don't count the numerous letters written at Rodez from the time he stayed there, addressed above all to his family and to his immediate entourage, the doctors taking care of him, in January 1945 he has not so far written except very briefly, to respond to precise queries, always on a loose sheet of paper, and at very specific moments. His drawing—of which he himself says that it is not without relation to his former writings, and to his attempts to renew the theater and restore to it the power it had lost—seems to be his first continuous activity. And he congratulates himself for being able to guarantee in part his existence thereby, which is, for him, to entertain some hope that one day soon his imprisonment might cease:

I started to do large colored drawings. I sent two of them to Jean Dubuffet[45] who had asked me to have them photographed, and I finished quite a few others. These are written drawings, with sentences inserted in the forms so as to precipitate them. I think that here I may have managed something special, as in my books or in the theater, and I am sure you will like them a lot. Perhaps I shall be able to sell them, and then between the money from my drawings and the money from my books, finally succeed in living by my own means.[46]

We should notice this very particular notion of written drawings which links drawing and writing, making them indissociable, lest we should imagine one without the other. We should also notice—this letter providing formal proof of it—that the execution of the first large

drawings preceded the obstinate, daily keeping of his notebooks (the first dates from February 1945), as if it had been necessary first to pass through this form of drawing writing, of ideographic writing, for his hand to get used once more to this major function which had been its province well before his internment: transcribing a thought upon paper or some other support.

We should remember here the whole thematics of the texts dealing with the Tarahumaras, relating that voyage when, going up the mountain on horseback, Antonin Artaud saw various forms coming forth from all sides, as if they had been drawn in the landscapes that surrounded him or engraved in the rocks, forms that finally resolved themselves into signs:

At every turning of the path there are trees burned deliberately into cruciform shape, or in the form of beings, and often these beings are double and face each other, as if to manifest the essential duality of things; and I have seen this duality indicated by a sign in the form of an H, enclosed in a circle, which appeared to me marked in red iron upon a great pine tree; other trees bore lances, spades, acanthus leaves surrounded with crosses; here and there, in enclosures of all sorts, there would develop great strangled corridors of rocks, or whole lines of Egyptian ankhs; and the doors of the Tarahumaras' houses would show the sign of the Mayan world: two opposed triangles, whose points are linked by a bar; and this bar is the Tree of Life which passes through the center of Reality.[47]

And surely these signs occupying the mountain, positioned there by "a sort of grandiose mathematics"[48] that caused them to repeat themselves according to certain numbers and obey their music, these signs composing on the sheer sides of the Tarahumaras' sierra a gigantic painting, animated by a secret alchemy into which "the pre-Renaissance Italian painters were initiated,"[49] were transformed by definitively denuding themselves into letters, with all their magic condensed into the simplified and archaic form of a letter:

Stone by stone, finally, and at the end of the voyage, I had the impression of having noted them all: from the stroke which divides itself into a double stroke, broken in its center by a bar, with across from it this same right bar which issued from it; and I cannot help it if this form of the H which results is the central figure upon which Plato recounts that the Atlantis inhabitants had built their towns. [50]

And the H is not the only letter that emerges spontaneously in nature for the Tarahumaras, the unique letter offered to the eyes of the one seeking, upon the slopes of mountains or the fronts of dwellings, the drawn/written traces of an ancient and vital secret. During the ritual ceremonies, it's an entire alphabet, organically produced by the bodies of the participants, excreted by their viscera, that appears in space, an alphabet through which a lost science will be able to rediscover itself, decode itself once more:

What came forth from my kidney or my spleen had the form of the letters of a very ancient and mysterious alphabet masticated by an enormous mouth, but frighteningly repressed, prideful, unreadable, jealous of its own invisibility; and these signs had been swept in all senses into space while it appeared to me that I was climbing upon them, but not all alone. Aided by a strange force. But much freer than when I was alone upon the earth. / At one moment something like a wind arose and the spaces withdrew. On the side where my spleen used to be, an immense emptiness dug in, painting itself in gray and rose like the shore of the sea. And in the depths of this emptiness there appeared the form of a fallen root, a sort of J which would have had at its summit three branches with an E on top, sad and shining like an eye. —Flames were leaping out of the left ear of the J and passing behind it, seeming to push everything to the right, on the side where my spleen was, but far beyond. [51]

Now, for Antonin Artaud, these letters dispersed in the air are so many signs whose multiple combinations reconstitute a sort of forgotten visual

representation like a painting, a magic painting that manages to represent even the mind. These letters that are born and fade away almost immediately in the atmosphere create, by their forms and the mutations of these forms originating in the body, a fluctuating picture that must "correspond objectively to a transcendental *painted* representation of the final and highest realities."[52] Showing what cannot be shown, representing the unrepresentable, expressing the inexpressible: this is what Antonin Artaud saw the sorcerers of Peyotl accomplish during their ritual, and what he will attach himself to at Rodez when he starts drawing again, then writing daily. And if the drawings are for him, as subsequently all the lines of the notebooks will be, the manifestation of a war undertaken against the evil forces dispersed in the world in order to prevent any lucid consciousness from speaking out, they are also a means for finding a profound reality once again:

Each line that I trace upon a drawing or that I write in a text represents in my consciousness an unlimited depth in life because of the resistance of everyone's consciousness, except for some very rare friends like you. We are not . . . on the real map of the world, and I have on this point an idea that other men do not, and I have found very few friends who, like you, have understood it. I would just have to have better food and more strength in order, by drawings or poems, to make a whole stretch of mad conscience collapse, and to permit other souls to reach at last what they have always been seeking: true life and the level on the true earth where what appears is only a masquerade.[53]

For Antonin Artaud, drawings and poems have an identical function, not so different from the kind of cure he would like to see the theater bring about, letters and signs concurring toward the same end, and so it is completely natural that drawing and writing should be linked to constitute what he himself calls, in the beginning of 1945, "written drawings."

Among the drawings that have come down to us, *L'Être et ses foetus* (Being and Its Fetuses) and *Jamais réel et toujours vrai* (Never Real and Always True) answer this definition, and must date from this period. In *L'Être et ses foetus*, space is split in two by a median body, which is probably being, with its head at the bottom, its armless torso on the interior of its trunk, and its shoulders resting on two unlikely looking feet, with its obviously female fetus placed in the opposite direction, so that its feet are parallel to those other odd-looking feet. Two other persons, slightly smaller than the internal foetus, and which are perhaps fetuses already outside of being, seem to float around on either side of its feet that are pointing upward. The remainder of the paper is spattered with diverse forms: bones, suns, wheels, larvae, ectoplasm, and a sort of mass armed with a spear in the upper part to the right. At the top and at the bottom, horizontally, to the left and to the right, vertically, inscriptions frame the whole picture. Two other vertical inscriptions can be read, one on the left, along the length of the mass, the other, as if aborted, with some letters purposely omitted, to the left of the central being. In addition, elements of glossolalia mingle in everywhere with the forms.

In the second of these drawings, between two horizontal inscriptions: "never real and always true" at the top, and "not from art but from / the failure of Sudan and of Dahomey" at the bottom, forms again fill up all the space. Except for some geometric elements at the bottom left, and, more in the center, a sort of little body without either arms or legs, surrounded by bubbles and reminiscent of those wooden Russian dolls that fit into each other, the forms are purposely larval, undecided:

The drawings I want to speak of are full of larval forms, in the very stubbing of the pencil stroke against the paper, and I wanted them to agree between themselves so that with the colors, the shadows, and all their reinforcements, the whole would be valid and singular.[54]

The largest of these forms is on the left and takes up the whole height of the space. It's an enormous trunk bristling with pseudopods like so many mollusks, topped with a kind of hat and finished off by a dotted appendix that seems at once soft and swollen. From its right side there emerge two monstrous legs, soft, edematous, and lower down, but in the center, a sort of drooping phallus. At the top of the sheet, to the right of this enormous form, four shields from which there protrude stakes or blades, the one on the far right seeming rather anthropomorphic. Beneath them there can also be seen, in the center, a person reduced to a head, a trunk, and a leg, with one vertebral column that appears to be escaping from him.

If I have dwelt at such length on the detail of these two drawings, it is because they seem to me characteristic of Antonin Artaud's procedure at that time. He has to take possession of the whole space, peopling it with signs and words, garnishing it in all possible directions with diverse weapons, without permitting the slightest breach to appear in which malevolent forces could go to work. Not one square centimeter is un-occupied. Just so, in February 1945, not one square centimeter of the notebooks will remain virgin, the writing and the hand will stubbornly blacken every part of the white page. The drawings, like the notebooks, are veritable war machines, and we notice, in those executed at Rodez, the frequency of cannons mounted on wheels, those cannons that spit forth fire or point toward the sky, like so many erect penises.

Two other drawings would also correspond to this notion of "written drawings": these are *L'Immaculée conception* (The Immaculate Conception) and *Dessin à regarder de traviole* (Drawing to Be Looked at Sideways), which appears, however, to be of a later date. Of the first, in fact, it is only known that it was done before January 1946, for it figures in a list drawn up by Antonin Artaud in that month; for the second, its commentary is located in a notebook from the end of January 1946, so it is certain that it had just been finished. But we know from a letter that Antonin Artaud

addresses to Dr. Ferdière on February 28, 1946, that on this date he could still conflate writing and drawing: "The sentences that I noted on the drawing that I gave you, I sought them syllable by syllable, aloud and working hard, to see if any verbal sonorities had been located that would be capable of helping anyone looking at my drawing to understand it."[55]

If the written parts of the drawing itself are there in order to help with a better understanding of it, what is the role of those texts that occasionally comment on them? Is it because his drawings were not always received as he would have liked that Antonin Artaud very often felt the need to illuminate them by further commentary? Or might it not be in order to prolong their resonance by accompanying them with a text which, read or, better, declaimed, would double the effects, while acting differently, affecting other points of our sensitivity? Either reason could easily motivate such a procedure. Unfortunately, the documents that have come down to us do not always permit us to associate the drawings and the commentary: certain commentaries have outlasted the drawings to which they could apply, not to this day found or identified; in other cases, we have the drawing or the trace that it existed, but not the commentary. The latter were not perhaps always written in a systematic fashion to apply to each drawing.

Those remaining have abundant information for us on the way in which Antonin Artaud then envisaged his drawings and his own relation to the inert matter that presented itself to him: the paper on which he was going to project words, objects, and phantoms of beings. The quality of the support matters little to him: "Fine paper encourages you to make masterpieces, coarse and repulsive paper encourages you to make useful and needed works that will no longer be able to pass as beautiful."[56] That the quality of the paper is mediocre does not bother him in the slightest. On the contrary, it obliges him to a harsher necessity, to a more acute vigilance, the paper being an adversary to conquer and that he has to

traverse—going far beyond it—so as to inspire the forms that the hand has precipitated upon it to go on and live, an adversary to be soiled, crumpled, scraped to the very limit of perforation, spoiled and set to shrieking. This virulent struggle of the idea to come to daylight, whatever bruises and wounds it takes, that's what these drawings should show us, exactly what Antonin Artaud wants to have art accept, exceeding the limits of art, as he wants it to admit the apparent clumsiness of the drawn line:

This drawing is a grave attempt to give life and existence to what until today had never been accepted in art, the botching of the subjectile, the piteous awkwardness of forms crumbling around an idea after having for so many eternities labored to join it. The page is soiled and spoiled, the paper crumpled, the people drawn with the consciousness of a child. / I wanted all this anguish and exhaustion of the consciousness of the seeker in the center and around his idea to take on some meaning for once, for them to be accepted and made part of the work accomplished, for in this work there is an idea. [57]

That a sheet has already been used does not bother him in the least, he turns it over and draws on the other side (this is the case for *Dessin à regarder de traviole* and for *Le Temps des lâches passera sous la guerre du canon* [The Time of the Cowards Will Pass under the War of the Cannon]), caring very little that traces of the other side may appear; of the fact that many forms have been drawn on the sheet itself, then wiped out without having been entirely effaced, and that there remains for it some sort of specter of a work destroyed, spotting the paper (so it is with the drawing whose center is a body hung on a gallows), he takes no notice; perhaps indeed he will incorporate these phantoms in his work like so many marks of his progress and, in his war against the support, he will induce some violence to surge forth from these wounds he has inflicted upon it, the violence doubling that of the drawing. He takes his pencil or his stick

(he uses pencil lead, colored pencils, the soft Crayola-type chalks) as he would a true weapon, in order to constrain the subjectile, ramming the point against the surface so hard it breaks or crushes. As for the forms that haunt these drawings: wheels, suns, cannons with often a highly phallic look, guns, sickles, toothed combs, blocks of wood, gallows, envelopes, coffins, telescopes, helmets, unformed cells, mutilated bodies, deprived of an arm or of both, sometimes having only a single monstrous leg, but perhaps possessing quadruple nipples and trunkless legs, heads without a body, traces of feet and a multitude of bones, all this mingling, as the title of one drawing describes it, in a "bouillabaisse of forms," Antonin Artaud deliberately refuses to present them skillfully:

This drawing, like all my others, is not that of a man who doesn't know how to draw, but of a man who has abandoned the principle of drawing and who wants to draw at his age, my age, as if he had never learned anything by principle, law, or art, but only by the experience of work, and I should say not instantaneous but instant, I mean immediately deserved. *Deserved in relation to all the forces that in time and space are opposed to the manual work of creation, and not only manual but nervous and physical. / That is, against the taking mental possession of the soul, and its restoration in the being of reality.*[58]

Of these drawings, themselves clumsily executed, "so that the eye looking at them will fall,"[59] which intend to have us perceive no one knows what unfathomable reality, which don't try to please us but rather to alert us, Antonin Artaud will say that they are "documents,"[60] or again, "sensations": "This drawing is a sensation that has passed into me, as they say in certain legends that death passes. / And that I have wanted to grasp in flight and draw absolutely *naked.*"[61]

And it is true that they are anything but a "lovely" kind of drawing, to which, moreover, the hand of Antonin Artaud could have laid claim,

as he proved in his youth: "I worked for *ten* years on drawing in the course of my whole existence / but I did not ever *despair* of pure drawing."[62] No, these drawings are not banal works of art, they bear witness to a gasping life and its anguish, they are the work of a man for whom the traversing of an alienating experience has forged an incomparable lucidity.

What Antonin Artaud accomplished with the first drawings done at Rodez is indissociable from the writing of the notebooks. From 1943, with "Le Rite du Peyotl chez les Tarahumaras" (The Ritual of Peyotl in the Tarahumaras)[63] and "L'Arve et l'aume" (The Larva and the Ell),[64] he had sufficiently demonstrated that his linguistic virtuosity was not only intact but had gained in force and in pertinence. But it is not the search for form that is his first concern when he writes, in the noisy solitude of an asylum of madmen, these thousands of pages day after day. What counts is to affirm by writing, as he does by drawing, a certain identity found again, to accumulate the materials, even inorganic ones, even larval, indispensable to the success of the work undertaken, to remake, to reconstitute his dislocated framework: "To say and write no matter what in order not to lose the idea so as to remember afterward, bringing forth the true framework, that skeleton of incarnation."[65]

But sometimes, as if in spite of itself, "style opened up, it was just going along its way,"[66] and that yielded some stupefying verbal explosions. That is also more or less what happens with drawing: at moments, the hand finds itself being skillful again, it knows how to accentuate the stroke, to distribute the dots, marblings, and speckles, to render exactly the black of the moiré pencil silvery, almost phosphorescent; the subject is moreover more limited, less diffuse, more centered on the sheet whose space is suddenly authorized to breathe, is more dramatically composed, as if staged. I am thinking here of *L'Exécration du Père-Mère* (The Execration of the Father-Mother), of this penis between two open legs and which with its end is jabbing into a death skull, placed there to signify the sex

of the woman, thinking of this tumultuous birthing catapulting under our eyes; I am also thinking of that head with the pupils shining like those of Medusa, with the mouth speaking, of which Antonin Artaud said that it had appeared to him in a dream; I am thinking of that drawing that he called, laughing, "the shit sweeper" where the most visible element is precisely that round broom with the totemic handle coiffed with a kind of colonial helmet, with an arched bit, and as if it were translucent,[67] which takes up the front of the stage, whereas at the back, at the left and very much withdrawn, hieratic, there reigns a being with a body almost wiped out, of which only a face can be seen, grim as death, the forehead slashed by the edge of the paper itself, the hollow eyes staring at us, one heavy and swollen breast at the level of the liver, and one foot with the toes spread wide apart.

Very few portraits[68] among the drawings of Rodez: on a detached notebook sheet, the lovely young woman, with a pure oval face, the pupils dilated in the extreme, perhaps Sonia Mossé[69] evoked from memory when Antonin Artaud learned of her disappearance in a gas chamber; a barbaric and brightly colored drawing (almost entirely executed with soft chalks) where he is symbolically represented as the king of the Incas, the body armless, almost without a torso, unless torso and arms are hidden under two round hummocks at chest height, all of that resting on two large paws at the feet of a winged animal;[70] finally, a self-portrait looking not very much like him, done on the eve of leaving Rodez (it is dated from May 11, 1946), through which shows the face of one of his two grandmothers (sisters in reality, whom he had made his first-born daughters: Neneka Chilé and Catherine Chilé). Scarred and gutted with wounds, dotted with points of pain, her face appears above a few other faces of unequal sizes in the lower part of the drawing.[71]

Now, as soon as he returns to Paris, he will abandon almost entirely drawings with any theme or portrait-like images. (I am of course speaking

here of the drawings that Antonin Artaud conceives as autonomous works, for which, like any other draftsman, he uses a specially chosen paper, but there are also, ever since 1945, the drawings of the notebooks to which I will return.) There are two exceptions: *M. Victor,* done at the request of the young actors who were putting on *Victor ou Les Enfants au pouvoir* (Victor, or The Children in Power) of Roger Vitrac, which was to have been reproduced in the program;[72] and a kind of primitive gri-gri, a mask or a totem, or a hand losing its bones and spreading out like a sulfurous flower, dating from April 27, 1947, done at the request of Prevel to illustrate one of his poems.[73]

The very first portraits are rather often smallish and seem to have been done to please the friends that Antonin Artaud had found again, or those who had found him again. Perhaps also he thinks he can earn his living by selling his drawings, as he had intended to, according to his letters, and even more easily if he becomes a portrait painter.[74] Wanting to prove himself in this domain, he then makes an attempt to render the picture more lifelike. So it is with the portrait of Rolande Prevel, where the musicality of line reminds us of certain drawings of Matisse, or those of Jacques Prevel, Pierre Loeb, or Sima Feder, for example.

But very soon, the face will stop being an object to reproduce, in order to become—upon the sheet where Antonin Artaud forms hatchings, stripes, wrinkles, scrunching his pencil down until it breaks off—the very theater of a war from which he will emerge devastated, panting, and shrieking with a truth never until then attained: "In the portraits that I drew, I tried above all not to forget the nose, the mouth, the ears, or the hair, but I tried to make the face that was speaking to me / tell the secret / of an old human history which passed by as if dead in the mind of Ingres or of Holbein."[75]

I remember Antonin Artaud very well as he was doing my portrait in November–December 1946. He had installed his sheet of paper on the

dining table in front of which he stood, with many pencils in reserve, as always, in the pocket of his jacket. He had seated me across from him, but didn't force me into immobility. At moments, he was completely absorbed by his work, sweeping his pencil over the paper or, suddenly stopping his movement, jabbing it hard into the paper, or then again squeezing his thumb against the page to give more nuance to the intensity of the blackened parts shadowing the forehead, the cheeks, or the chin. He would lift his head from time to time, looking at me with his vivid blue eyes whose eyelids he wrinkled to better discern the detail he was trying to isolate and wanted to bring to the fore. But he could also hum or joke, without however relaxing his attention. I saw him return with insistence to one definite spot of my face, tinker with it, passing his pencil again and again over the same spot, making it gleam like mica, wiping it out, starting over again. It went on for several days. The result was surprising, magnificent, but terrifying. Antonin Artaud looked at me, looked again at his drawing, then again at me at last, declaring: "I have given you the face of an old empire of barbarian times." And it was true. I am sorry not to be able to see that portrait again today;[76] I have the impression that Antonin Artaud had shown an extraordinary prescience in it, and that his drawing revealed in advance the face that life was going to give me.

The face, for him, is the compendium of innumerable signs that have marked it during a life past and present, but also to come, as if the traces left on it by the anguish lived through could somehow signal ahead of time what life would imprint in each of its wrinkles. The face, which is everything we have left of a true body, is unlikely to betray us, quite the contrary from the body: "The human face is conditionally, / I say conditionally, / everything that remains of the *revenge*, / of the *revolutionary* revenge of a body that is not and never was in conformity with that face."[77]

Just as, with the Tarahumaras, the liver and the kidney and the spleen of the participant, during the ritual, produce an alphabet that decodes the unrevealed mysteries, so the face produces signs, inscribed in its very skin, that offer to the draftsman, if he knows how to comport himself as a poet, that is to say, as a seer, the possibility of reading a destiny therein. And that is what Antonin Artaud does when he draws a face—he strips it bare, making the most secret things it contains stand out, unveiling for him what it will be: "My portraits are those that I have wanted to represent, / they themselves wanted to be, / it's their destiny that I have wanted to represent without worrying about anything other than a certain barbarity, yes, a certain unschooled CRUELTY, but who could find it in the middle of the species?"[78]

Not the slightest esoterism in that, no trace of allegory either in any of these portraits. Antonin Artaud represents what he sees, but what he sees is well beyond what all the others can perceive, and he knows it also perfectly well, he says it himself, what he wants to represent and how and why he does it in this way.

One of the first portraits done in Paris is that of Jean Dubuffet,[79] on the afternoon of August 27, 1946. And it is not without importance that it should be the portrait of a painter. Leaving the studio of the rue de Vaugirard where he lingered, engrossed in his work, Antonin Artaud runs afterward to the rendez-vous that he had set with Prevel, and to explain his lateness, recounts what he has just done, saying he had looked for whatever seemed to be troubling in the face of his model.[80] During the course of the visit Jean Dubuffet, who, in the days before, had done from memory two portraits of Antonin Artaud,[81] shows them to him. These portraits suprise him, mostly because a cross has been drawn in the place of his nose, whereas he himself wants to have nothing in common with the Christian religion. And in fact, in the drawings of Jean Dubuffet, a sort of cunningly naive four-petaled flower—the petals opposed two by

two, and whose form might indeed evoke a cross—is stuck in just the place where a nose should be found. The very fact that Antonin Artaud, so sensitized to everything that had to do with religion that the least hint on this subject could provoke in him an extreme fury, appeared to be both amused and intrigued by the drawings that were presented to him, shows that in some way he had appreciated the anti-pictorial procedure of the painter. Nearly a year afterward, the impression still remains because he notes: "Is M. Jean Dubuffet academic when he paints and when he protests / the nose under the eye sockets / against the ocular academism of the present architecture of the face said to be pictorial?"[82]

That he should refer to the drawings of Jean Dubuffet in order to define antiacademism is not insignificant, since he defends himself against being thought academic in deciding to show the face exactly as it is constructed: forehead, eye sockets, nasal appendix, lips, and hair. And to show that his way of proceeding is far from academic, he chooses precisely as an example his own portrait of Jean Dubuffet:

Is Jean Dubuffet academic because he has two eyes, lips, a mouth, a verbal emission that serves him to contradict the principle itself of expression? / No, and yet his skull is there, like mine, both of which one day will be lit with the lights of I don't know what tomb that will exist, I say it right now, that of an ossuary of the disinterred. For our bodies, we the living, according to all the persons represented in the latest exhibitions of paintings, will not have to be buried in order to have at last the mortuary honors of a poem like one of François Villon's.[83]

Until about April 1947, Antonin Artaud uses only a lead pencil, and usually contents himself with placing a single face rather high on the sheet of paper, sometimes without a neck, sometimes with the neck as if severed from the torso, right where it should be attached to the shoulders, a face that he chisels with rage, that he ravines, ravages, or on the contrary,

in certain cases, feathers in with a light hand in order to better preserve a sort of fundamental ingenuousness; I am thinking, among others, of the portrait of Domnine Thévenin, six years old, the only portrait of a child he ever did, or of that of Colette Thomas, dated May 21, 1947, looking like Ophelia with eyes of a black lake, continually astonished by existence. The same face can also be perceived, according to the moment of the portrait, or the relation of Antonin Artaud to his sitter that day, in an absolutely different way. To see side by side, for example, the portrait of Mania Oïfer dated January 12, 1947, and the one of her in May of the same year is a singular proof of that. It's the same young woman who posed, of course, but where the first, with her diaphanous smooth skin, the studied looseness of her hair, her far-off sad look, is already no more than a memory of herself, the second permits us to glimpse the depths of an immense life. Antonin Artaud has gone, as it were, far beyond appearance; he shows what there is of permanent, almost unfathomable distress in these eyes that he circles with very deep wrinkles; he hammers and chips away at the face, rubs down its planes, makes quite sparse the hair surrounding the face like a mourning veil, this face he sculpts, we might say, for a sort of eternity, like that of a barbarous and dolorous divinity.[84]

It's that he never did intend to make something agreeable to look at: "poor, dry, and servile should be the drawing."[85] He has taken great care to warn us about this; none of these portraits whose gazes go right through us are "works of the aesthetic simulation of reality."[86] No, each of them has been, at the moment when he projected it upon the paper, constructed it, modeled it, mistreated and animated it, the very center of a drama where the hand of Antonin Artaud which drew it precipitated it, a hand always conscious that "cruelty is above all lucid, it's a sort of rigid direction, the submission to necessity. No cruelty without consciousness, without a sort of deliberate consciousness. It's consciousness that gives to the exercise of any act of life its color of blood, its cruel nuance, because it is clear that life is always the death of someone."[87]

It's the conscientious hand of Antonin Artaud that gives this force that bores right through you to these faces, this power of piercing the heaviest darkness, it is its cruel lucidity that gives them life, a life they have not suspected until then, which gives it to them at the price of the death it obliges them to live when they contemplate themselves, it's he who leads them, with their eyes wide open, to meet their destiny. And it is in that way that he reaches the sense of theater: "Now the theater is like a great wake, in which it is I who am guiding fatality."[88]

The portrait of Jacques Prevel, dated April 26, 1947, seems to be the first where, in order to better express this fatality, the head, with its bumpy, deformed forehead and its eyes of unequal size, the left one smaller than the right, and implanted much lower, is no longer isolated upon the sheet, but, on the contrary, bordered and as it were invaded by a text which seems placed there in order to make his tragedy more vivid still.

Starting at this moment, just when he knows surely that his portraits are going to be exhibited and will have to act upon a public, Antonin Artaud picks them up again, reworks them, surrounds them with signs, objects, sentences, uses chalks and colored pencils again, mingling them or contrasting them with the anthracite of the lead pencil: "I commit you," he writes me on June 18, 1947, "to coming back here to see what I have done with your portrait. I have surrounded it with signs, with objects. / I have done the one of your sister too as in the wheat fields of a van Gogh." And it is true that the portrait of my sister glows and spins like certain canvases of Vincent van Gogh, that painter who is "only a painter,"[89] who was, like Antonin Artaud, declared mad and enclosed in an asylum. In the preceding months, we must not forget it, he wrote, in a burst of solidarity, driven and motivated by the similarity of their two destinies, one of the most upsetting books any writer was ever to write about a painter. The blazing of colors in the canvases of Vincent van Gogh, the look of his self-portraits that drills through you, the dramatic intensity of his last

compositions, he managed to have all this *seen* with nothing but words, thanks to the evocative power he was able to breathe into them, through the gathering of sonorities and the internal scansion of their structure. To succeed in that took the eye of a painter, but a painter who had to be at the same time a fabulous poet, for whom the theater had always been the "magic of living,"[90] for whom, "if theater doubles life, life doubles the true theater."[91]

They are living, all these human heads that Antonin Artaud draws in 1947, they have the power to haunt anyone who has once seen them; their decapitated faces interrogate you with all the force of their absent bodies, absent perhaps because they are judged by him to be madly constructed, but which all the same carry those faces and bear them on. If he sometimes insists so strongly upon a particular aspect of their face, if he plunges his pencil so hard into that point, imprinting a round and very black mark, it is that "to know the localizations of the body is . . . to remake the magic chain."[92] If he sometimes forces "objects, trees, or animals" to protrude from their sides, it is, he says, because he is not yet "sure of the limits at which the body of the human self can stop."[93] The human body, for him, is above all the body of the actor, "that formidable animated fetish which is the whole body / of a whole actor."[94] Now the only time that he is asked how one of his portraits should be entitled, the one of Henri Pichette, he answers that this drawing is a gri-gri.[95] Speaking of the portrait of Jany de Ruy, he declares that he has made of it an armed head.[96] It is truer still of the portrait of Henri Pichette. One part of the hair forms a sort of band encircling the head, letting some bangs escape; the forehead, the cheeks, the nose, the chin are marbled, hammered, clawed; the violence of the shadows makes the clarity of the look come out all the brighter; the neck supporting the head is narrow as a knife blade, and shows numerous wounds; a spherical abscess, swollen to bursting, with nail heads sticking out, stretches the skin at the height of

the Adam's apple: "the shrieking ball" ready to explode; the left side of the neck is also bristling with these same nails of which we see only the points and which seem to have been stuck in from the inside. It's the portrait of a warrior after the battle.

In each of the lines that Antonin Artaud writes, in each of the gestures that he makes, the reference to the theater is constant, if only implicit. The operation that he undertakes when he hurls one of these faces without members into life is a theatrical act, whence the undeniable dramatic power of his portraits. And it is no mere chance if, when Pierre Loeb wishes the close of the exhibition "Portraits et dessins" to be marked by a reading of texts,[97] Antonin Artaud writes, in order to read it as a prologue, "Le Théâtre et la science," where he affirms that the theater is "this crucible of fire and of true meat where anatomically, / through the stamping down of bones, of members, and of syllables, / the bodies are remade, / and the mythical act / of making a body is presented / physically and naked."[98] Isn't it in an identical crucible that he has kneaded and masticated the faces that offered themselves to him to make them into truer faces?

When it is a matter of Antonin Artaud, how should we separate into genres, set limits to categories? Theater, poetry, writing, drawing are so inextricably mingled, still more in the last two years of his life, that it is scarcely possible to speak of writing without evoking drawing or of the latter without theater or poetry coming forth: "Poetry is multiplicity churned up and sending forth flames."[99] They are so devouring, these flames, that words fail to speak of his very last drawings, these forests of intermingled faces sometimes haunted by his own, these accumulated heads erected as totems, these landscapes constellated with eyes, syllables, or words, that he peoples with dead women[100] of whom he makes living ones, and living ones who must pass through death in order to live. How

to evoke the violence or the sparkling of the blacks and the grays he obtains with his pencil alone and the back of his thumb?

And what to say of this extraordinary self-portrait, curiously dated December 1948, as if he had signed it already dead,[101] where he has represented himself with an emaciated face whose parchment skin lets the bone structure show through? He said to me, in signing and dating it: "This is myself on the road from the Indies five thousand years ago." About the head on his right shoulder: "It's the head that weighs on me." As for the object below, and lower than his neck, in the center of the thoracic cavity, he explained to me that it's a coffee machine, the coffee machine, probably, that with its steam should enable the body to function. Of the living man, of the man of flesh that he was, there remains only the strong right hand with two fingers raised. It is holding something from which one ear is sticking out, an ear or perhaps a handle, for he had spoken to me about a hidden teapot.

The last drawing he finished, around the beginning of 1948, is also the only one from this period for which he used colored chalk, and one of the very rare ones where the sheet is used horizontally.[102] I looked at it closely hundreds and hundreds of times without perceiving that it was signed at the bottom on the right and dated November 18, 1946, and that is because the date and above all the signature are largely covered over and as if hidden by the colored drawing itself, thus anterior to it. This must have been originally a drawing with pencil lead, first left aside for I don't know what reasons, then picked up and worked on for several months.[103] This prolonged cohabitation of Antonin Artaud with his drawing has without a doubt much to do with the feeling of satisfaction that it arouses. We feel the long labor accomplished by him day after day, as it bears the still vivid traces of the passage of his hand and of the contact of his fingers with the paper. It would not seem possible to go further, to reach deeper with a simple pencil and some soft chalks.

The sort of rolling machine that is found at the top, in the center, is doubtless the only element, done in a rather hard pencil (the same used for the signature and the date), that remains from the initial drawing. Some glossolalia had been scrawled in the same pencil at the top and the bottom of the drawing. They have been covered over by a second inscription in black chalk, with the exception of the line traced along the upper edge. Outside of that, not a great deal can be discerned from the original drawing. It disappears under the wide heavy strokes of the colored chalks whose predominant colors are the ochres and the blue. Antonin Artaud told me that he wanted to represent the projection of the true body. He himself stands on the left, with his entire body, his hands in manacles, chains on his feet; his knees with the protruding kneecaps seem tied up by a kind of bracelet spitting out flames or knife blades. His severed hands are tied by a cord that, having traversed the space of the drawing, goes around a barbaric being behind him, on the right, probably his double, wearing the mask of an African sorcerer crowned with feathers or flames, his feet resembling those of the king of the Incas, whose fantastic oblique body projects itself all over as if he were ejaculating spurts of flame. The cord, having wrapped itself around him, grows thicker and joins a kind of ring that seems to encircle his thighs. From his left shoulder comes another cord that ends in a closed curl, and heads like a lasso toward the thighs of the tied-up body. Between them an army of soldiers marches, among whom several are aiming their weapons at the immobile body of Antonin Artaud whose face, modeled in black pencil and surrounded with blue chalk, is lightly silvered. "The theater," he will write on February 24, 1948, "is in reality the *genesis* of creation."[104] Isn't this exactly what this drawing is, and should one not consider it as the supreme setting for the Theater of Cruelty?

Antonin Artaud considered as finished, so that he could add nothing to them, two magnetic human panoramas with their profusion of faces

being born night after night or day after day on the paper, from which there surges forth a subterranean magic, and where the eye, attracted in all the directions of space, is lost. But his last drawing he could not finish. The central form evokes a totem from Ireland, made of heads piled one on top of the other, the upper head being by far the largest, with its features more sculpted than drawn and a severe expression. Antonin Artaud dominates the left side, standing upon a body without arms, a body like a trunk of wood. He seems to have a woman's breasts. Between himself and the totem, at the height of his hips, appears an army of little beings. To the right of the body, at the extreme left of the drawing, are sketched my portrait and that of my sister. On the right, a person of whom only the head is clearly indicated, a head with a monstrous right ear and a mouth full of enormous teeth. At the height of his abdomen a sort of little gnome. All the rest of the drawing is only just started. It seems obvious nevertheless that Antonin Artaud picked up in it and prolonged the same theme of the last colored drawing: the projection of the real body.

The drawings of Antonin Artaud have something unique about them, and it would be absurd to try to make them enter in some fashion or other into the history of art;[105] just as foolish as it would be to compare them to other poets' drawings, from William Blake to Henri Michaux. Only, perhaps, by the whirling and the sharpness of the lines, the persistent presence of the hand, do the drawings of Giacometti exercise sometimes this same fascination, but they do not possess to the same degree this mixture of cruelty and tenderness, this vigorous passion. We do not meet in them these reliefs of faces whose skin is of an unequaled transparency or on the contrary darkened by a thousand years of life, reliefs due to the very particular work of the thumb, nor those astonishing glances of those eyes open upon we cannot know what nights.

This unique quality in his work is just such a total confusion between the drawing and the writing, just such an impossibility of separating them. Upon this Antonin Artaud always insisted:

And since a certain day in October 1939[106] I have never again written without drawing. / Now what I am drawing / these are no longer themes of Art transposed from the imagination onto the paper, these are not affecting figures, / these are gestures, a word, a grammar, an arithmetic, a whole Kabbala and which shits at the other, which shits on the other, / no drawing made on paper is a drawing, the reintegration of a sensitivity misled, it is a machine that breathes, / this was first a machine that also breathes. / It's the search for a lost world / and one that no human language integrates / and whose image on the paper is no longer that world but a decal, a sort of diminished / copy. / For the true work is in the clouds.[107]

So, these drawings, and still more perhaps those of the notebooks, have the same characteristics of structure, the same skeleton as the writing because they are said to have their own grammar. These are never inert forms, laid out on paper, but mechanics of thunder produced by breathing, in which theater always exists in the present:

I say / that for ten years with my breath / I have been breathing forms hard, / compact, / opaque, / frenetic, / forms without curves / into the limbo of my body not made / and which from this fact is made / and that I find each time the 10,000 beings to criticize me, / in order to block the attempt on the verge of a pierced infinite. / Such are in any case the drawings with which I constellate all my notebooks.[108]

The first graphic signs other than the letters giving form to the words that appear in the notebooks, around May 1945, are so many dots scattered at different places on the page, so heavily incised by his hand that the hollow of their trace is perceived two, four, or even six pages further on. The gesture that Antonin Artaud must have made to inscribe such heavy marks in the paper is certainly the same one that I saw him repeat hundreds of times when, having discovered on his back, or his head, or

any other part of his body a spot of particular pain, he would stick into it the point of his pencil or his knife, pressing as hard as possible for several minutes. The first objects he drew are generally found in the margins; relatively geometrical in shape, they are often crosses, taus, coffins. Then there are womens' bodies, sometimes deprived of their arms and with very large breasts, almost always studded on their whole surface with a multitude of very black dots. Sometimes elements of one or the other of the large drawings have been sketched in the notebooks.

Upon his return to Paris, all the fury contained during his nine years of asylum set on fire the amassed materials, provoking a conflagration of words and forms. The drawings in the notebooks, of which it cannot be determined if they are at the source of the text, aiding its explosion, or if they accompany and prolong it, these drawings which in any case, as in the great "written drawings," are indissociable from the writing,[109] transformed. Almost always done with pencil lead, they are black, shining, carbonized. The solid hand of Antonin Artaud, this "worker's hand"[110] whose vigor is so clearly suggested in the last self-portrait, the one of the road from the Indies, passes and passes again a hundred times over the same line. Always the same relation, this struggle against the subjectile, this same will to conquer it without sparing it, to vanquish it, to draw from it still more than it can give.

Sometimes figurative (there are several portraits, and even this astonishing self-portrait with the knife dug into the skull, with the wide blade reaching the root of the nose), they frequently represent weapons of torture: dial-machinery, iron collars, wedges, nails, plaques bristling with nails, gallows, winches, stakes, and also coffins, blocks of wood, machines, boxes, they can become fantastic shapes, difficult to identify. Sometimes it happens that whole pages have no drawing on them; that occurs in general if Antonin Artaud is writing in ink, far less convenient for making those signs that punctuate the virgin pages. If he uses a pen,

it is almost always that he is carried away by his subject. So it is with the pages written for *Van Gogh le suicidé de la société* (Van Gogh the Man Suicided by Society). But then the writing itself, the breathing space between the words, the slope of the lines, the form of the letters that, as in the Tarahumara mountain, metamorphose into as many signs, all this concurs to make of the whole page a graphic design, a reflection of the impulse that guided the hand.

How to separate the writing from the word, the drawings from the writing, how to define them because to define is to separate and to condemn to death; "A thing named is a dead thing, and it is dead because it is separated."[111]

These drawings that are not drawings, that cannot be defined, that are just as much words as what he terms *trumeaux* ["piers" or "pier glasses"] (and the old meaning, the first meaning of the word *trumeau* is leg, the calf of the leg), these drawings are living, they are there, upon the written page, but they are also elsewhere, further off, they do not die, their birth is uninterrupted:

these are not drawings, / they do not figure anything, / do not disfigure anything, / are not there to construct, / edify, / institute / a world / even abstract, / these are notes, / words, / trumeaux, / *they are ardent, / corrosive, / incisive, / spurting forth / from I don't know what whirlwind / of under-maxillary / under-spatulary / vitriol / for they are there as if nailed down / and destined no longer to move, /* trumeaux *then, / but making their apocalypse / for they have said too much about it to be born / and have said too much in being born / not to be reborn / and take on their body / then authentically.*[112]

And these drawings, these members gathering themselves together to take on a body, they would be nothing if we did not leave the written page. To understand them, Antonin Artaud tells us, once having left this

written page we must furthermore "enter into the real,"[113] an operation that would be insufficient if afterward we did not leave "the real, to enter into the surreal,"[114] into which they plunge us and from which they come, these drawings that "are in fact / only the commentary of an action that has really taken place, / the figuration / on the circumscribed paper / of a thrust that has taken place / and has produced magnetically and magically its effects."[115]

Just like the word, these drawings are "breathed,"[116] they are produced by the breath, by the whole body of the man Antonin Artaud who says it: "they are purely and simply the reproduction on paper / of a magical gesture / that I exercised / in real space / with the breath of my lungs / and my hands, / with my head / and my 2 feet, / with my trunk and my arteries, etc."[117] The man writing that is the one who wanted "with the hieroglyph of a breath to find again an idea of the sacred theater,"[118] who for long years thought that breath had to accompany every effort, that it "relights life,"[119] and that, nourishing life, breathing "permits us to climb back up the stages by the steps";[120] so he now knows "the visual, objective value of the breath."[121] Writing, singing, or drawing, he is not only writing, singing, or drawing, he is working with his whole body and with his breath rising from the most profound depths of his lungs, summoning and creating a world through written words, uttered or drawn, words or consonances "which act."[122]

Then these drawings themselves, these violent objects/acts hurled into space, "What are they? / What do they mean? / The innate totem of man. / The amulet to come back to man."[123] Conjuring objects, like those spells, they are breathed out, expelled with all the force of respiration "to assassinate magic," to bring back "the time when man was a tree without organs or functions, / but made of will, / and a tree of a will on the march."[124] Fashioned for exorcism and war, the pencil lead gives them the flash of metal. They shine, like black weapons, they flash like bonfires to

help in piercing through the shadows, in triumphing over the innumerable enemies of the true human body. Their reason for being is not aesthetic: it is, profoundly, that of disbanding the troops of nothingness, these "beasts without will or proper thought, / that is, without proper pain, / without the acceptance in them of the will of a proper pain, / and who have not found any other means of living / than to falsify humanity."[125]

May–August 1984

Notes

1. A third drawing, with highlights in color, is also signed: it is a postcard composed by Antonin Artaud, but whose date we know: July 1921. I would think it more likely that the so-called Châtelard landscape, because of this same postcard format, must date from 1920–1921.

2. This portrait was reproduced in *La Tour de feu*, no. 63–64 (December 1959), p. 18, with this inscription: "Portrait of one of Dr. Dardel's patients, painted by Antonin Artaud." Pierre Chaleix, who took the photograph, published in the same issue an interview he had just had with Madame Toulouse: "Before Surrealism/ Artaud at Dr. Toulouse's" (pp. 55–60), in which he alluded to this charcoal drawing and the page on which it was reproduced: "My attention has been taken for the last few moments by two little drawings under glass that Madame Toulouse is going to get down. . . . They are charcoals by Antonin Artaud, with violent contrasts, portraits of a sick woman patient of Dr. Dardel." Now these two charcoals were exhibited at the National Book League, with the caption: "Two charcoal sketches of a patient at Villejuif," which would make the young woman a patient of Dr. Toulouse. This last supposition may have been just some-thing the cataloguer deduced, for a few months later, Madame Malaus-séna, in giving these two drawings to the Swedish Cultural Center, entitled them: "Portraits of the patient B., 1920," which could just as easily be a patient of Dr. Dardel in the beginning of 1920 as a patient of Dr. Toulouse from the end of March 1920. So we have preferred to stick with the first indications given by Madame Toulouse, some twenty years earlier.

3. II, 171. In the short references to Artaud's work, the roman numeral refers to the volume of his *Oeuvres complètes* (Paris: Gallimard, 1956ff.), and the arabic numeral to the page of this volume.

4. II, 172.

5. Ibid.

6. Ibid.

7. V, 33.

8. II, 173.

9. The play was included again in the repertory for the 1923–1924 season, and then for the 1926–1927 season, but never produced.

10. I met Yvonne Gilles in 1949–1950, and she told me she had done a portrait of Antonin Artaud, so it was a true exchange.

11. Antonin Artaud, *Lettres à Génica Athanasiou* (Paris: Gallimard, 1969), p. 46.

12. III, 111, letter to Yvonne Gilles about November 22, 1923.

13. One of the texts that make up *L'Ombilic des limbes* (The Umbilicus of Limbo) has as its title "Paul les Oiseaux ou la Place de l'Amour" (Paul the Birds or the Place of Love) (cf. I, 54–56), whose theme was taken from "Paolo Uccello," in *Vies imaginaires* (Imaginary Lives) by Marcel Schwob. A first version of this text was called "Drame mental" (Mental Drama). The fact that Antonin Artaud chose to illustrate one of his first theoretical texts on the theater by these two schemas seems to indicate that he had intended to provide a scenic transcription of *La Place de l'amour*.

14. Max Jacob, *Lettres aux Salacrou* (Paris: Gallimard, 1957). Letter of October 19, 1924: "I know how the genius raises his glass and puts on his socks. Artaud raises his glass like the profound man he is: I am not using the word genius in vain. . . ."

15. III, 126.

16. V, 121.

17. VII, 481, n. 3.

18. I, 62.

19. I, 147–148.

20. André Breton, *Entretiens* (Interviews) (Paris: Gallimard, 1952), p. 110.

21. II, 15.

22. Ibid.

23. II, 27.

24. II, 35.

25. Ibid.

26. Ibid.

27. II, 23.

28. IV, 52.

29. Ibid.

30. IV, 58.

31. IV, 61.

32. IV, 38.

33. IV, 91.

34. IV, 69.

35. IV, 116.

36. VIII, 258.

37. Text of February 1947.

38. V, 121.

39. Text of February 1947.

40. Ibid.

41. Ibid.

42. In an article entitled "Antonin Artaud chez Gaston Ferdière" (Antonin Artaud at Gaston Ferdière's) (*La Tour de feu*, no. 63–64 [December 1959], pp. 75–78) Delanglade gives his own version: "From that day, I mean in the month that followed the electroshock therapy, Artaud was transformed. He really began to initiate himself afresh into creative activity. Profiting from the occasion and with the totally gratuitous goal of distracting him, I led him into the studio where I painted just for the pleasure of it, in order to 'amuse' him with colors. That's where he sketched very carefully my portrait in charcoal, which he wiped out and began again several times. It was the start of a far more serious picture production."

We do not know if it is in order to flatter his friend Gaston Ferdière that Delanglade attributes the regaining of interest in drawing to the electroshock therapy, but it is certainly obvious that he shows, during his en-

tire account, an extraordinary disdain for Antonin Artaud; it is impossible to say if it is simply a lack of breeding or silliness that enables him to declare: "To be done with Artaud, you have to be aware that the literature of madmen has in it works far more poetic than those of Artaud, whom I reproach for not having had a talent—let's not even say the word genius—at the level of the exceptionally fortunate adventure that he was able to have as soon as he was placed in the keeping of Dr. Ferdière."

Given what these lines reveal of the behavior of Frédéric Delanglade concerning Antonin Artaud, it is in no way surprising that the latter, scarcely out of Rodez, should have judged him more than harshly. In the part of his journal published under the title *En compagnie d'Antonin Artaud* (In the Company of Antonin Artaud) (Paris: Flammarion, 1974), Jacques Prevel relates (p. 18) this conversation with Antonin Artaud on June 3, 1946: "He speaks to me about a painter, someone named Delanglade, who has some of his drawings. An ignoble individual, he says."

43. X, 196, a letter of February 5, 1944, to Dr. Ferdière.

44. Antonin Artaud, *Nouveaux écrits de Rodez* (New Writings from Rodez) (Paris: Gallimard, 1977), p. 131.

45. Jean Dubuffet did not receive the drawings, presumably given by An-

tonin Artaud to the secretariat of the asylum to be sent to him, because he answers on January 15, 1945: "You say that you sent me two large drawings in color, and I haven't received anything at all."

46. XI, 20, a letter of January 10, 1945, to Jean Paulhan.

47. IX, 38.

48. Ibid.

49. IX, 63.

50. IX, 102.

51. IX, 26.

52. Ibid.

53. XI, 81–82, letter to Dr. Jean Dequeker, at the end of April 1945.

54. XIV, 77. This postscript to a letter addressed to Henri Thomas on February 12, 1946, was added to refer to a sentence concerning some "drawings in a notebook" that Jean Dubuffet had seen during a visit to Rodez some months earlier. However, because of the allusion to colors, it seems to apply above all to the large drawings. Those of the notebooks are indeed in graphite pencil.

55. Artaud, *Nouveaux écrits de Rodez,* p. 113. (The letter is given as a fragment whose beginning is supposed to

have been lost. In fact, it is an addition to the letter of February 28, 1946.)

56. XXI, 238.

57. XIX, 259. Commentary on *Dessin à regarder de traviole.*

58. XX, 340.

59. XX, 170. Commentary on *La Maladresse sexuelle de dieu.*

60. XXI, 266.

61. XXI, 232. Commentary on *La Mort et l'homme.*

62. XXI, 266.

63. IX, 11–30.

64. IX, 133–146.

65. XX, 295.

66. XIV, 26.

67. Prevel, *En compagnie,* relates (pp. 11–15) his first visit to Ivry on May 29, 1946, during which Antonin Artaud showed him the drawings brought back from Rodez:

"Monsieur Dubuffet," he says, showing me a drawing, "told me that he had never seen a drawing possessing such a nervous intensity." It's a very strong drawing in black pencil, a woman's face convulsed in terror,

with her breast at the height of her abdomen. Beside it, a tree. It's this tree that occasioned Dubuffet's remark.

A few minutes later, Artaud will explain to Dr. Delmas: "It's a chamberpot knocked over by a broom."

It's obviously the drawing just alluded to that he is talking about. But we have to take account of the fact that Prevel wrote in his journal once he had gone home, that he must have seen a rather great number of drawings, and that in his memory he mixed up the broom handle with a tree. As for the helmet with the handle, it could, of course, be seen as a chamberpot if it had a flat bottom. Let's say that it is between a chamberpot and a colonial helmet, and that it is composed of both.

68. We have to remember the portrait that Antonin Artaud was supposed to have done in charcoal of Delanglade (cf. note 42), about which we do not know if it was ever finished, nor its whereabouts if it was.

69. Roger Blin, who had been a close friend of Sonia Mossé, recognized her in this drawing.

70. Prevel, *En compagnie*, p. 13, describes a drawing shown on this same day of May 29, 1946: "Another admirable drawing, brightly colored, wild in its inspiration. A face is distinguishable above the flames." He is undoubt-edly speaking of the king of the Incas, but between the moment when he saw this drawing and the one when he wrote these lines, the blazing up of the colors must have imposed itself on him like a fire and he will remember it as flames.

71. This self-portrait, which was then part of Dr. Ferdière's collection, was reproduced for the first time in *La Tour de feu*, no. 63–64 (December 1959), p. 24, with this caption: "Self-portraits of Antonin Artaud done at Rodez in 1944 and showing in a gripping fashion his tactile and synesthetic hallucinations. / At the bottom left, the sketch of a nurse on duty." Because the portrait is signed and dated and, besides, of a completely different style from that of the very rare drawings done in 1944, we can take the date of 1944 mentioned in *La Tour de feu* for a mistake. The plural of the word *self-portraits* would seem to imply that Antonin Artaud is represented more than once. Only the face on the far right could be a second self-portrait, but I admit that I am not at all convinced of it. Some twenty years ago, Dr. Ferdière, showing me one day the original of this drawing, was still presenting it as a self-portrait, adding that the general overseer of the psychiatric hospital at Rodez, Madame Régis, was in it too. But more recently, Florence de Mérédieu, in *Portaits et gris-gris* (Portraits and Amulets) (Paris: Editions Blusson, 1984), p. 69, about this

same drawing said this: "Always desig-
nated until now as a self-portrait of
Antonin Artaud, the drawing seems to
us rather to represent Dr. Ferdière sur-
rounded by his medical team. Ques-
tioned on exactly this point, Gaston
Ferdière does not entirely rule out this
possibility, even specifying that the
person on the bottom left is no other
than Madame Rouquette in charge of
the pharmacy at Rodez." This hypothe-
sis seems to me without any founda-
tion whatsoever. In fact, in the same
issue of *La Tour de feu*, both Dr. Fer-
dière and Dr. Dequeker formally tes-
tify that Antonin Artaud did his self-
portrait at Rodez and that it is exactly
this drawing of May 11, 1946. In a
brief text, "Birth of the Image," which
happens to be placed just across from
the reproduction of the drawing, Jean
Dequeker recounts how he saw An-
tonin Artaud working several days in
order "to create his double," to have
his own face appear on a sheet of pa-
per. As for Dr. Ferdière, in an article
entitled "J'ai soigné Antonin Artaud"
(I Took Care of Antonin Artaud), pp.
28–37, he is still more precise: "He de-
liberately ripped up his work; I just
managed to save the self-portrait that
is shown in this issue; I said to him,
in all sincerity, what interest I found
in it; after a brief reflection, he gave it
to me." Even if such proofs did not ex-
ist, there would be still less doubt
about this drawing being a self-portrait
because Antonin Artaud himself recog-
nizes it as such. I have myself noticed

that it does not look much like him,
but, if we examine it attentively, we
can find some constants between this
drawing and two other self-portraits:
that of December 17, 1946, and the
one that, undertaken a year later, re-
mained unfinished. The way the hair
grows is indicated in identical fashion.
The treatment of the eyes and the
mouth, very straight and taut, is the
same.

72. The play was picked up again by
the Company of the Thyase, under
Michel de Ré's direction, on the stage
of the Théâtre Agnes Capri-Gaîté-
Montparnasse from November 12,
1946, and given on the days there was
no regular performance. *M. Victor* is
dated November 5, 1946. The planned
program was not even printed (cf.
Prevel, *En compagnie*, p. 90), presum-
ably for financial reasons. It should
have also contained a text of Antonin
Artaud. This text seems to have disap-
peared now. Having been given to Mi-
chel de Ré, it was placed by him in a
suitcase confiscated for default of pay-
ment by a not very understanding ho-
tel proprietor. The drawing will be
offered subsequently to Colette Al-
lendy in memory of the performances
at the Théâtre Alfred Jarry.

73. In his journal, *En compagnie*, pp.
122–123, Prevel tells of having accom-
panied Antonin Artaud to my home.
That day, while he was working in my
portrait, Prevel made three sketches of

him that were reproduced in the "Artaud" issue of the magazine *Obliques* (no. 10–11, December 1976, p. 202). At one moment when they were alone in the room, Prevel asks him if he can illustrate one of his poems. Antonin Artaud accepts. "He asks me," writes Prevel, "for a sheet from my notebook and makes me a terrifying drawing, extraordinary in evocative power." Prevel customarily used sketchbooks that were 20.5 x 27.5 centimeters, which gives us the probable dimensions of the drawing by Antonin Artaud, whose whereabouts we do not know. His story is dated April 28, 1947. However, the drawing by Antonin Artaud and one of the sketches made by Prevel the same day are both dated April 27, 1947. It is true that in his journal the entry for April 27 follows the account of the 28th, which is inexplicable unless we decide that the 28th indicates the day when he draws up the tale of the facts that happened the day before.

This drawing will be reproduced as the frontispiece of the copies numbered 1 to 100 of the collection of Prevel's poems: *De colère et de haine*, a collection that opens precisely with the poem for which the drawing was done (Paris: Editions du Lion, 1950); a large portrait against a background of text, dated April 26, 1947, was the frontispiece for the copies numbered 101 to 200. The drawing of April 27, reproduced in the catalogue of the exhibition "Paris-Paris" (Centre Georges Pompidou, May 28–November 2,

1981, p. 157), although it was not in the exhibition, was afflicted with this erroneous caption: *Portrait de Jacques Prevel, 1947*. This monumental error is reiterated afterward, each time the drawing is reproduced.

74. All in all, Antonin Artaud would do only two commissioned portraits that were paid for as such, the one of Michel Tapié de Celeyran and the one of Louis Broder. We have not been able to discover their whereabouts.

75. "Le Visage humain . . . ," a text included in the catalogue of the exhibition "Portraits et dessins par Antonin Artaud" (Galerie Pierre, Paris, July 4–20, 1947).

76. Included with two other portraits of me exhibited at the Galerie Pierre, it was the only one not returned. Disturbed by this, I asked Pierre Loeb about it, and received the answer that it had been lost during the framing.

77. Text of June 1947.

78. Ibid. [In French, Antonin Artaud puts a circumflex on the word *espèce*, even marking it twice above the letter.]

79. Antonin Artaud will later do the portrait of Lili Dubuffet. The two drawings were entrusted in July 1947 to the Galerie Pierre for the exhibition "Portraits et dessins." According to the information that was furnished us by

the office of Jean Dubuffet, one of them, inexplicably, was not returned after the exhibition. The other was given by Jean Dubuffet to his brother-in-law.

80. Cf. Prevel, *En compagnie*, p. 60.

81. Jean Dubuffet did three portraits of Antonin Artaud: *Portrait d'Antonin Artaud*, pencil and gouache, August 1946; *Antonin Artaud cheveux épanouis*, pencil and gouache, August 1946; *Antonin Artaud aux houppes*, oil on canvas, January 3, 1947. *Catalogue raisonné des travaux de Jean Dubuffet* (Paris: J. J. Pauvert, 1964ff.), vol. 3: "Plus beaux qu'ils croient (portraits)," by Max Loreau.

82. Text of June 1947.

83. Ibid. The text of June 1947 from which we have cited extracts is a first version of the one in the catalogue, "Le Visage humain . . .".

84. Mania Oïfer, who became Mania Germain, remembers Antonin Artaud saying to her, after having finished the portrait dated January 12, 1947, that he had seen her as an "Elizabethan sylph." About the one of May 1947, done on a day she was not well, he offered this explanation as the picture he gave of her frightened her: "It isn't the outside I wanted to show, but the inside." Mania Germain thinks that the last one chronologically is the one of January 12, 1947. However, it is the date of May 1947 that Antonin Artaud inscribed under his signature, at the bottom of the second one. More than once we have found mistakes about the day or the date, and some errors in the year, but it is not likely that you can make a mistake about the month, even if just because of the weather or the length of days. Besides, the three portraits of Mania Germain, the third one dating from September 1946, smaller in size, were done before June 1947 because, making up the list of drawings he wanted to exhibit at the Galerie Pierre, Antonin Artaud notes: "Mania Oïfer, 3 portraits."

85. XX, 131.

86. "Le Visage humain . . .".

87. IV, 98.

88. IV, 145.

89. XIII, 48.

90. IV, 144.

91. V, 196.

92. IV, 146.

93. "Le Visage humain . . .".

94. "Aliéner l'acteur," *L'Arbalète*, no. 13 (Summer 1948).

95. This portrait was done and given to Henri Pichette to use as a

frontispiece for the *Apoèmes* (Paris: Editions Fontaine, 1947). Henri Pichette had asked what Antonin Artaud wished to say about it. I myself transmitted the answer to him; it was: "with a gri-gri by Antonin Artaud."

96. Cf. Prevel, *En compagnie*, p. 148.

97. There were, in fact, two readings of texts. The first was for just the friends Pierre Loeb had invited on the evening of the vernissage, July 4, 1947. Antonin Artaud announced the recital of texts by Colette Thomas, who read one text on the theater, "Aliéner l'acteur" (To Alienate the Actor), and Marthe Robert, who read "Le Rite du Peyotl chez les Tarahumaras" (The Ritual of Peyotl in the Tarahumaras), this latter reading punctuated by cries and noises by Antonin Artaud, who was hidden (cf. Prevel, *En compagnie*, p. 150). Roger Blin, although he was present, read nothing that evening. On the 6th, Antonin Artaud wrote him to ask for his participation in the reading of Friday the 18th, which took place in front of an invited public. "Le Théâtre et la science" (Theater and Science) was written between July 5 and July 18. Antonin Artaud read it at the beginning of the evening. Then a recital by Colette Thomas of "Aliéner l'acteur" and by Marthe Robert of the text she had already read on the 4th. On the 18th, Antonin Artaud procured a gong that he beat with a large poker to accom-

pany "Le Rite du Peyotl." Roger Blin ended the performance by reading "La Culture indienne" (Indian Culture) (cf. Prevel, *En compagnie*, p. 155, and *Combat* of July 25, 1947).

98. "Le Théâtre et la science," *L'Arbalète*, no. 13 (Summer 1948).

99. VII, 84.

100. In order to get a better likeness of Yvonne Allendy, whose face appears in several of his last drawings, Antonin Artaud had asked her sister Colette for a photograph of her.

101. Giving me very precise instructions for framing it (a black mask, with a beading of dark garnet-red, the color of dried blood), Antonin Artaud signed and dated the portrait in the first days of 1948, whence his error concerning the year. As I pointed it out to him, he refused to correct it, telling me it had no importance. In December, he had also undertaken another self-portrait but did not finish it. The hair, in particular, is barely sketched in.

102. Besides this drawing, to my knowledge, the portrait of Alain Gheerbrant is the only one where the face is put in the center of the sheet spread out horizontally. It is possible that among the drawings done at Rodez, all trace of which seems to be lost, there are some horizontal ones.

103. On June 10, 1947, Prevel, *En compagnie*, p. 144, notes the following: "Artaud twisted the poker from his fireplace, beating it until it became a twisted piece of iron in the form of a snake. He yelled, shrieked, and battled the spirits furiously. Suddenly he attacked the drawing hung on the wall, adding flames to the personage representing him there. These flames went straight through his chest. 'Now it's becoming something,' he says." It could be that this is just the drawing in question, which would testify to Antonin Artaud's retouching it repeatedly.

104. XIII, 147.

105. No more than there was any direct influence of Antonin Artaud on the theater, but only a few references, partial borrowings, contradictions, or various alibis, and a basic impossibility of thinking of the theater without his name coming up, and, more or less partially, what he wrote about it. Strictly speaking, there is not any direct influence in the visual domain; there cannot be any to the extent that his drawings bear witness to a lived experience, and are, as he says, gestures. This is exactly why, in certain contemporary painters, we see one or another of his self-portraits appearing just as a quotation, for example, in *Starting to Sing: Artaud*, 1981, by Julian Schnabel, or in *Léger et Antonin Artaud*, 1983, by Erró.

106. Antonin Artaud must be making an allusion to the spells he was making at Ville-Evrard, but it was in May and not in October 1939.

107. "Dix ans que le langage est parti...," *Luna-Park*, no. 5 (October 1979).

108. Ibid.

109. Antonin Artaud insisted on illustrating *Artaud le Mômo* (Paris: Bordas, 1947) with drawings taken from his notebooks, an additional proof that he did not dissociate his poems from his drawings.

110. "Main d'ouvrier et main de singe" (Worker's Hand and Ape's Hand), *K: Revue de la poésie*, no. 1–2 (June 1948).

111. VII, 51.

112. "50 dessins pour assassiner la magie" (50 Drawings to Assassinate Magic). Antonin Artaud had planned to publish a book, edited by Pierre Loeb, where fifty drawings chosen from his notebooks would be reproduced. To introduce them, he wrote this text on January 31, 1948. Then he gave me the responsibility of choosing in his notebooks fifty drawings from those that seemed to me the best. The project was never completed, because Antonin Artaud died shortly thereafter, on March 4, 1948.

113. Ibid.

114. Ibid.

115. Ibid.

116. Here we have to reread the text that Jacques Derrida entitled, precisely, "La Parole soufflée," in *L'Ecriture et la différence* (Paris: Editions du Seuil, 1967), and tell him how much we owe him for having opened the way for a new reading of Antonin Artaud. The word that is *stolen/breathed* is a word *robbed* as well as *inspired.* But it can also be a word which, precisely because it is *soufflée,* because it is organic, succeeds, by the work of the breath, in finding once more on the inside of the body what had been taken away from it.

117. "50 dessins pour assassiner la magie."

118. IV, 146.

119. IV, 128.

120. IV, 129.

121. "50 dessins pour assassiner la magie."

122. Ibid.

123. "Dix ans que le langage est parti . . .".

124. Letter to Pierre Loeb, April 23, 1947, *Les Lettres nouvelles,* no. 59 (April 1958).

125. Ibid.

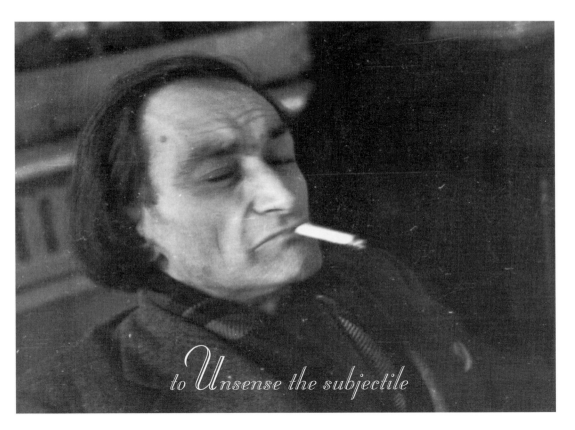

to Unsense the subjectile

Jacques Derrida

I would call this a scene, the "scene of the subjectile," if there were not already a force at work prepared to diminish the scenic elements: the visibility, the element of representation, the presence of a subject, even an object.

Subjectile, the word or the thing, can take the place of the subject or of the object—being neither one nor the other.

Three times at least, to my knowledge, Antonin Artaud names "what is called the subjectile." He says exactly that: "what is called . . .". Indirect naming, invisible quotation marks, an allusion to the discourse of the other. He uses the word of the others but perhaps he will have it say something else, perhaps he will tell it to do something else.

All three times, he is speaking of his own drawings, in 1932, 1946, and 1947.

Nevertheless, is it likely that he really ever *spoke about* his drawings? And above all, that we can or are able to? We won't tell the story of the subjectile, rather some record of its *coming-to-be*.

The first time (later we will pay attention to what only happened *once* for Artaud), on September 23, 1932, he concludes a letter to André Rolland de Renéville like this: "Herewith a bad drawing in which what is called the subjectile betrayed me."

Wait a minute: a subjectile can betray?

And wait a minute: when Artaud evaluates his painting or his drawings, when he badmouths them ("a bad drawing"), a whole interpretation of what is bad is behind this. Already in 1932, it is not simple to figure out what he is indicting here: it is not only a question of technique, of art, or of skill. The indictment is already leveled at god, is denouncing some treason. What must a subjectile do to commit treason?

In 1932, the word could seem to have been recently created. The current dictionaries then had not yet admitted it to the spoken tongue. So the legitimacy of a "subjectile" remains in doubt. Paule Thévenin (who

has said everything that has to be known about Artaud's drawings and whose work I am presuming everyone knows)[1] judges it necessary to be more precise in a note: "Perhaps it's in the part torn from this letter that the drawing was to be found. Antonin Artaud, having considered it too revealing, must have removed it, tearing off the bottom of the page. He certainly wrote 'subjectile.'"[2]

This note tells us at least two things. First, a drawing can *be a part of* a letter, which is completely different from just accompanying it. It *joins* with it *physically* because it is only separate by dint of being "the part ripped off." And then *to betray* can be understood in a very particular sense: to fail in one's promise, belittle the project, remove oneself from its control, but in so doing to *reveal* the project as it is thus betrayed. Translating it and dragging it out to broad daylight. Betraying the subjectile would have made the drawing "too revelatory," and of a truth sufficiently unbearable for Artaud to destroy its support. This latter was stronger than him, and because he had not mastered the rebel, Artaud is said to have snatched it away.

"He really wrote 'subjectile.'" Paule Thévenin warns those who, because they do not know this rare word, might be tempted to confuse it with another.

With what other word could we have confused the drawing itself, that is, the graphic form of the "subjectile"? With "subjective," perhaps, the nearest possible treason. But so many other words, a great family of bits and snatches of words, and Artaud's words are haunting this word, drawing it toward the dynamic potential of all its meanings. Beginning by subjective, subtle, sublime, also pulling the *il* into the *li*, and ending with projectile. This is Artaud's *thought*. The body of his thought working itself out in the graphic treatment of the subjectile is a dramaturgy through and through, often a surgery of the *projectile*. Between the beginning and the end of the word (*sub/tile*), all these persecuting evils

emerging from the depths to haunt the supports, the substrata, and the substances: Artaud never stopped naming, denouncing, exorcising, conjuring, often through the operation of drawing, the fiends and the succubi, that is the women or sorcerers who change their sex to get in *bed* with man, or then the vampires who come to suck your very substance, to subjugate you to steal what is most truly yours.

Through the two extremities of his body, such a word, itself subjectile, can, like the drawing of a chimera, mingle with everything that it is not. Although it seems so close to them, it lures them toward the illusion of an entire resemblance: the *subj*ective and the pro*jectile.*

What is a subjectile? Let's go slowly, not rushing things, learning the patience of what is developing, and make it precise: what is "called the subjectile"? For Antonin Artaud doesn't speak of the subjectile, only of what "is called" by this name. To take account of the calling, and what is called. A subjectile first of all is something to be called. That the subjectile *is something* is not yet a given. Perhaps it comes across as being *someone* instead, and preferably something *else:* it can betray. But the other can be called something without being, without being a being, and above all not a subject, not the subjectivity of a subject. Perhaps we don't know yet what "is called" like this "the subjectile," the subjectility of the subjectile, both because it does not constitute an object of any knowing and because it can betray, not come when it is called, or call before even being called, before even receiving its name. At the very moment when it is born, when it is not yet, and the drawing of Artaud situates this *coup de force,* a subjectile calls and sometimes betrays. That's what I can say about it to begin with.

At least in this language. In French, we think we have just found out recently what the word "subjectile" means currently. We believe it to be contemporaneous with Artaud. Contemporary dictionaries date it from the middle of the twentieth century. But they are wrong, they are really

reactivating an old word, French or Italian.* The notion belongs to the code of painting and designates what is in some way lying below *(subjectum)* as a substance, a subject, or a succubus. Between the beneath and the above, it is at once a support and a surface, sometimes also the matter of a painting or a sculpture, everything distinct from form, as well as from meaning and representation, not representable. Its presumed depth or thickness can only be seen as a surface, that of the wall or of wood, but already also that of paper, of textiles, and of the panel. A sort of skin with pores. We can distinguish two classes of subjectile, by a criterion that will decide everything in Artaud's way of operating: in this apparently manual operation that is a drawing, how does the subjectile permit itself to be traversed? For we oppose just those subjectiles that let themselves be *tra-*

* I am adding *three* details, which all depend on texts I have just become acquainted with, after this manuscript had already gone to the printer.

1. As for the "Italian" source, I refer to the letters of Pontormo to Varchi, edited by Jean-Claude Lebensztejn in *Avant-guerre*, no. 2 (1981), pp. 52–55. Here we read: "Sculpture is such a dignified and eternal thing, but this eternity has more to do with the marble quarries of Carrara than with the value of the Artist, because it is a better subject for that, and this subject, which is to say, relief." Lebensztejn notes here that "subject, *soggetto*, designates the material substance of art, its substratum, *subjectum, hypokeimenon*." "Pontormo's argument about the subject," he adds, "was already present in Leonardo (without a subject). We find it again in Bronzino's letter to Varchi (with a subject)." This time it is "in più saldo subbietto."

2. The very beautiful book that Georges Didi-Huberman just published with the title *La Peinture incarné* (Paris: Editions de Minuit, 1985) calls the subjectile "the old notion of the *subjectile*" and refers to Jean Clay to whom "we owe its theoretical reestablishment" (p. 38).

3. Paule Thévenin has just given me a text she recently discovered, which Artaud seems to have read. The word *subjectile* appears in it *three times*. It is an article that Tristan Klingsor devoted to Pierre Bonnard in 1921 (in *L'Amour de l'art* 2, no. 8 [August 1921]):

The use of a subjectile so rarely used before, that is, cardboard, facilitates his work. The way the cardboard absorbs so readily lets him get rid of the oil colors. . . . In addition, Pierre Bonnard, with a seeming negligence, lets this subjectile show through here and there. Since it is rather warm in nuance, generally golden, it contrasts with the cold tones laid down by the painter and gives them the most exquisite finesse. Even better, it guarantees a general harmony to the work. . . . Once the nuances of cardboard have been discovered, the artist will use them in his canvas, he keeps his orchestration in changing the subjectile.

versed (we call them permeable or *porous*, like plasters, mortar, wood, cardboard, textiles, paper) to the other impermeable ones (metals or their alloys) that permit no passage.

About the subjectile we would have to—yes—write what is untranslatable. To write according to the new phrasing, but discretely, for resistance to translation when it is deliberate, noisy, spectacular, we already know it has been repatriated. In truth its secret should only be shared with the translator.

A subjectile appears untranslatable, that is axiomatic, it sets up the struggle with Artaud. This can mean at least two things. First, the word "subjectile" is not to be translated. With all its semantic or formal kinship, from the subjective to the tactile, of support, succubus or fiends with a projectile, etc., it will never cross the border of the French language. Besides, a subjectile, that is to say the support, the surface or the material, the unique body of the work in its first event, *at its moment of birth,* which cannot be repeated, which is as distinct from the form as from the meaning and the representation, here again defies translation. It will never be transported into another language. Unless it is taken over bodily and intact, like a foreign substance. So we shall be able to conclude: (1) What exceeds translation really belongs to language. (2) What so drastically exceeds linguistic transfer remains on the contrary foreign to language as an element of the discourse. (3) The word "subjectile" is itself a subjectile.

How to measure the consequences of this paradox? I will dare to claim that we have to embroil ourselves in the paradox in order to get anywhere near the painted or drawn work of Artaud. This spatial work would be first of all a corporeal struggle with the question of language—and at the limit, of music.

No way of passing over this fact: what I am writing here in French, in a language that was up to a certain point and most often that of Artaud, is first appearing in a language said to be foreign. You are reading in

German here* what was first intended to offer a subtle resistance to trans-
lation. But since you are reading me in German, it means that this text
has nevertheless been translated, whereas at no moment would one have
thought of translating the drawings or the paintings, nor indeed the
words or phrases contained in them—in Artaud's own hand. Incorpo-
rated, that is to say, inscribed in the graphic corpus *in the very substance* of
the subjectile.

To challenge the foreigner, not in order to write in good old French,
but on the contrary to perform an *experiment*, to *translate* the crossing of
my language, to the point of forcing the French, my natural language, the
only mother tongue able to serve as an ultimate support to what I am
calling upon first. The French language is the one in which I was *born*, if
you can put it like that, and in which *I find myself* even as I debate with it
or against it. I am writing *from within the substance* of the French language.
(How will they translate that?)

Now at the moment of speaking the language said to be maternal, I
remember the last stop of the subjectile, the ultimate occurrence of the
word *in the hand* of Artaud. Father and mother are not far off: "The figures
on the inert page said nothing under my hand. They offered themselves
to me like millstones which would not inspire the drawing, and which I
could probe, cut, scrape, file, sew, unsew, shred, slash, and stitch without
the subjectile ever complaining through father or through mother"
(1947).

How can an untranslatable subjectile betray, we were wondering just
a moment ago. What must it have become now, in the return of the word
fifteen years later, in order never to complain "through father or through

* At the moment when these pages were written they were supposed to appear first, in fact only, in German
translation.

mother," at the moment when I am attacking its unresisting body with so many *coups de force* and in so many ways, giving myself up to him in order to give him so many operations, when the surgeon that I am demands to probe, cut, scrape, file, sew, unsew, shred, slash, and stitch?

What had happened in the interval (1932–1947)? Something? An event, once, on such and such a date?

> *And since a certain day in October 1939 I have never again written with-*
> *out drawing.*
> *Now what I am drawing*
> *these are no longer themes of Art transposed from . . .*[3]

No longer to have to transpose, to translate. Must we write against our mother tongue to do that? Precisely in order to *render* what is un-translatable?

But no one can say calmly that French was Artaud's only mother tongue, nor that language is just a support, as you might say of a paper or a textile, of a wall or a panel. Unless you treat it in its turn as a sub-jectile, this sort of subject without a subject, with this manner or this maneuver betraying the whole story in an instant, in fact the story of a betrayal. Being and god would be implicated in this trial of the subjectile: perversion and malfeasance, subterfuge or swindle.

So it would be necessary, while drawing by hand, to write against this language, and have it out with the so-called mother tongue as with any other, making oneself scarcely translatable, starting from it but also within it (I am speaking of *Auseinandersetzung*, of *Übersetzung*, and, why not, of *Untersetzung*), in it where I am supposed to have been *born:* but where I was still, Artaud would say, in the twist it imposes on the syntax of this word *innate.* This supposed natural tongue, this tongue you are born with, it will be necessary to force it, to render it completely mad,

and in it again the subjectile, this word that is scarcely even French, in order to describe the support of the pictogram that is still resonating with the trace left in it by a projectile. This came to perforate its sensitive but sometimes resistant surface, the surface of a subjectivity appeased and reassured: the precarious outcome of the work.

The Germans don't have any word *subjectile,* although they were the first to project this great corpus of Antonin Artaud's pictograms, and to publish it separately, even though it is inseparable. As certain dictionaries tell us, we didn't have this word in French either a short while ago, but at least it suits our Latinity. The Germans—think of Fichte or Heidegger— have always tried to take back their language from Rome. Artaud too, and this isn't the only thing they have in common, however horrifying this seems to some. In other conditions, with time enough and taking the necessary precautions, I would be tempted to insist on the possible encounters which did not take place between Heidegger and Artaud. Among many other themes, the one of the *innate* and the *Ungeborene* in Heidegger's reading of Trakl, and the question of being, quite simply, and of *throwing* [*jeter*] and of *giving* [*donner*].

Artaud, then, against a certain Latinity. What he says on this subject about the *mise-en-scène* is also valid, as is always true, for the pictogram and for what doesn't necessarily happen or does so only through words:

In opposition to this point of view, which strikes me as altogether Western or rather Latin, that is, obstinate, I maintain that insofar as this language is born on the stage, draws its power and its spontaneous creation from the stage, and struggles directly with the stage without resorting to words . . . it is mise-en-scène *that is theater, much more than the written and spoken play. No doubt I shall be asked to state what is Latin about this point of view opposed to my own. What is Latin is the need to use words in order to express ideas that are clear. Because for me clear ideas, in the theater as in everything else, are ideas that are dead and finished.*[4]

The Germans have no subjectile, but how would we know that without Artaud, who doesn't only use it but attacks it, quarrels with it openly, seduces it, undertakes to pierce it through, puts it through the wringer, and first of all, names it? Not so much in order to dominate it but to deliver from a domination, to deliver someone or something else that isn't yet born. He attacks it like a Latin word. Without having any fear of the word: like a Latin thing, like this historical sedimentation of a thing and a word consolidated near subject and substance, from Descartes's "clear ideas."[5]

I don't know if I am writing in an intelligible French. To unsense the subjectile, is that still French?

Forcené, this word that I wanted to decompose surreptitiously, subjectilely, in *for, fort, force, fors,* and *né,* letting all the words in *or, hors, sort* incubate in it, I thought it was limited to its *adjectival* usage as a past participle. The infinitive seemed to me excluded, foreclosed in fact, and I thought I was inventing it for a cause requiring some forcing of language. But that isn't it at all, for *forcener* exists, even if its use is rare and outmoded. But only in an *intransitive* form. You can't *forcener un subjectile* in French without forcing the grammar of the word at the same time. *La forcènerie* or *le forcènement*, the act or the state of the *forcené*, consists simply, and intransitively, in *forcener* or in *se forcener,* that is to say, losing your reason, more exactly, your *sense*, in finding yourself *hors sens*, without sense (*fors* and *sen*). The etymology the Littré dictionary gives seems reliable in this case: "Provençal *forcenat*; Italian *forsennato*; from the Latin *foris, hors* [outside], and the German *Sinn, sens* [sense]: outside of your senses. The spelling *forcené* with a *c* is contrary to the etymology and incorrect; it isn't even borne out by traditional use, and only comes from an unfortunate confusion with the word *force,* and it would be far better to write *forsené*." The word would then correspond with the German *Wahnsinnige* about which Heidegger reminds us that it doesn't initially indicate the state of a madman (*Geisteskrank*), of someone mentally sick, but what

is without (*ohne*) any *sense*, without what is sense for others: "*Wahn* belongs to Old High German and means *ohne:* without. The demented person [*der Wahnsinnige*, which we could translate in French as *forsené*] dreams [*sinnt*] and he dreams as no one else could. . . . He is gifted with another sense [with another meaning, *anderen Sinnes*]. *Sinnan* originally means: to travel, to stretch toward . . . , to take a direction. The Indo-European root *sent* and *set* mean path."[6]

I am sure that what I am writing will not be translatable into German. Nor into Artaud's language. Should I be writing like Artaud? I am incapable of it, and besides, anyone who would try to write *like* him, under the pretext of writing *toward* him, would be even surer of missing him, would lose the slightest chance ever of meeting him in the ridiculous attempt of this mimetic distortion. But we should not give in either to the kind of judgment *about* Artaud that will not be, any more than his name, the subject or the object, still less the subjectile of some learned diagnosis. All the more because it is a matter of his drawings and his paintings, not only his speech. Moreover, and we can verify this, he himself never writes *about* his drawings and paintings, rather *in them*. The relation is different, one of imprecation and argument, and first of all one that relates to a subjectile, which is available for a support.

We cannot and should not write *like* Artaud *about* Artaud who himself never wrote *about* his drawings and paintings. So who could ever claim to write *like* Artaud *about* his drawings or paintings?

We have to invent a way of speaking, and sign it differently.

Yes or no, we must have done with the subjectile, a mime might say. And he wouldn't be wrong, for we are spectators of the scene: in this matter of the subjectile, it is certainly a judgment of god. And it is certainly a matter of *having done with it*, interminably.

Let's give up for the moment.

Even though a subjectile signs in advance, *for Antonin Artaud*, in this place of precipitation, even of perforation, in the very moment when such

a projectile touches the surface, we have to learn not to be in a hurry to seize, to understand, we have to give the ink of so many words depositing themselves slowly in the thickness of the body time to get absorbed: exactly the thickness of the subjectile whose nature we still do not understand. Does it even have an essence?

So let's not rush to the question: what is a subjectile? What is being when it is determined as a subjectile?

The word should be translatable in German, since it has to go outside of French to return, crossing the border several times. Unless it should itself institute the border that it forms between *beneath* and *above* (support and surface), *before* and *behind, here* and *over there, on this side* and *on that, back* and *forth,* the border of a textile, paper, veil, or canvas, but *between* what and what? How can we enter, by perforation or deflowering, into what has no consistency apart from that of the between, at least unless we lend it another one?

No doubt the Germans will insert the Latin word like a foreign body in their own language: intact, untouchable, impassive. Perhaps that is just as well. The meaning of this bodily struggle with the subjectile will probably have been: how do you address a foreign body? What about skill [*adresse*] and awkwardness [*maladresse*] in relation to the foreign body? What about prosthesis? What about that "artificial fecundation" which Artaud protests, so as "to have done with the judgment of god"?

A subjectile is not a subject, still less the subjective, nor is it the object either, but then exactly what is it, and does the question of "what" have any meaning for what is *between* this or that, *whatever it is?* Perhaps the *interposition* of a subjectile is what matters, in this matter of drawing by hand, in this maneuver or meddling [*manigances*].

First of all let's give up trying to be ever *in front,* face to face with the pictograms that will never be *ob-jects* or subjects present for us. We won't be describing any paintings. The paradigm of the subjectile: the table

itself! We won't even speak of it if *to speak of* means to speak about objects or subjects.

But if a subjectile is never identified with the subject or the object even when it occupies their place and being, is it the same as what Artaud so often likes to call a *motif*? No, it would *prevent* the motif, but the very counterforce of this prevention sets up an extreme tension. What exactly is a motif, then? "For what is the motif?," Artaud asks in *Van Gogh le suicidé de la société* (Van Gogh the Man Suicided by Society), implying by the question that a motif is nothing, but so singularly nothing that it never lets itself be constituted in the stasis of a being. This word *motif* (how will they translate that?) has the certain advantage of substituting the dynamics and the energy of a motion (movement, mobility, emotion) for the stability of a *-ject* [jet] which would set itself up in the inertia of a subject or object. When he gives up describing one of van Gogh's canvases, Artaud inscribes the *motif* in the center of the "forces" and the *writing* forces ("apostrophes," "streaks," "commas," bars," etc.), with these acts of "blocking," "repression," "the canvas," and so on as protagonists. Here we have to quote, starting with "How easy it seems to write like this," the whole page that prepares the question: "For what is the motif?"

So I shall not describe a painting of van Gogh after van Gogh, but I shall say that van Gogh is a painter because he recollected nature, because he reperspired it and made it sweat, because he squeezed onto his canvases in clusters, in monumental sheaves of color, the grinding of elements that occurs once in a hundred years, the awful elementary pressure of apostrophes, scratches, commas, and dashes which, after him, one can no longer believe that natural appearances are not made of.

And what an onslaught of repressed jostlings, ocular collisions taken from life, blinkings taken from nature, have the luminous currents of the forces which work on reality had to reverse before being finally driven together and, as it were, hoisted onto the canvas, and accepted?

There are no ghosts in the paintings of van Gogh, no visions, no hallucinations.

. . .

But the suffering of the prenatal is there.[7]

The fact that later on van Gogh is credited with having had "the audacity to attack a subject" doesn't mean that there was any subject for him, no matter how simple, even if it happened to be "of such disarming simplicity." In the flow of this way of speaking, it can be understood that the subject precisely attacked was no longer going to be one, or shouldn't be one any longer. And this is the following paragraph: "No, there are no ghosts in van Gogh's painting, no drama, no subject, and I would even say no object, for what is the motif? / If not something like the iron shadow of the motet of an ancient indescribable music, the leitmotiv of a theme that has despaired of its own subject. / It is nature, naked and pure, seen . . .".[8]

We don't know what this motif is—neither this nor that—it doubtless no longer even belongs to being, nor to being as a subject. If it is "of nature" we shall have to think of nature completely differently, and the history of nature, the genealogy of its concept, in other words of its *birth* and conception: up to the *innate* [*inné*], this neologism of Artaud where nature collides with its contrary, what is not born in what seems to be innate, the "suffering of the prenatal" which appears as a monstrosity.

Under the surface of the word, and under the sense, *hors sens,* the passage from *motif* to *motet* doesn't obey only the formal attraction of the words, the *mots, motifs,* and *motets,* although when you let the attraction play under the meaning, you draw or sing rather than speaking, you write the unwritable. No, this passage also convokes the multiplicity of the voices in a motet in painting. It promises something essential in what Artaud still understands by painting: an affair of sonority, of tone, of

intonation, of thunder and detonation, of rhythm, of vibration, the ex-
treme tension of a polyphony.

This should be read like a book about music, according to Artaud.
The "ancient indescribable music" tears apart the veil of a birth, revealing
"naked nature," the origin whose access has been forbidden by this "na-
ture," concealing even the source of this interdiction. The leitmotiv, this
really musical motif of painting, its guiding force and its major aesthetic
passion, must not be confused with a *theme,* the meaning of an object or
a subject, such as it could be *posed* there. A theme is always posed or
supposed. The leitmotiv for its part doesn't always answer in itself like a
stable support: no more a subjectile, this last is carried away by the motif.
The property of a theme is what an expropriation has deprived us of, and
it is as if we had been deprived of our own memory, distanced from our
own birth. Across the "prenatal suffering," we cannot meet back up with
innate nature (*in-né*) except by forcing the subjectile, rendering it *unsensed
from birth.* You have to make it frenetically desire this birth, and to un-
sense it from the outset in making it come out of itself to announce this
next proximity: "It is nature, naked and pure, seen as she reveals herself
when one knows how to approach her closely enough." Music, nature,
seeing: the same: seen [*vue*]. Such a proximity confines you to madness,
but the one that snatches you from the other madness, the madness of
stagnation, of stabilization in the inert when sense becomes a subjecti-
vized theme, introjected or objectivized, and the subjectile a tomb. But
you can force the tomb. You can unsense the subjectile until—unsensed
from birth—it gives way to the innate which was assassinated there one
day. A violent obstetrics gives passage to the words through which, how-
ever, it passes. With all the music, painting, drawing, it is operating with
a forceps.

Of course, Artaud was speaking of van Gogh here. But without giving
in to a cliche such as "speaking of van Gogh he is speaking of himself,"

and so on, we still have to recognize that Antonin Artaud couldn't have entered into that *relationship*, into the realm of the relation with van Gogh, except in *giving himself* over to the experiment that he is describing just at the moment when he is refusing to describe the stability of a painting.

And this experiment is the traversal of this *jetée*, its trajectory. I am calling spurt or *jetée* the movement that, without ever being *itself* at the origin, is *modalized* and disperses itself in the trajectories of the *objective*, the *subjective*, the *projectile*, *introjection*, *objection*, *dejection*, and *abjection*, and so on. The subjectile remains *between* these different *jetées*, whether it constitutes its underlying element, the place and the context of birth, or interposes itself, like a canvas, a veil, a paper "support," the hymen between the inside and the outside, the upper and the lower, the over here or the over there, or whether it becomes in its turn the *jetée*, not this time like the motion of something thrown but like the hard fall of a mass of inert stone in the port, the limit of an "*arrested* storm," a dam. Giving himself over entirely to this, hurling himself into the experience of this throwing [*jetée*], Artaud could enter the realm of relationship with van Gogh. And all the questions we will listen to from now on will continue to resound: what is a *port*, a *portée*, a *rapport* if the subjectile is announced as the support of the drawing and painting? What does the carrying, the carrying over [*porter*] mean in this case? And throwing, hurling, sending? Is spurting [*la jetée*] a mode of sending or of giving? Might it be rather the inverse? Must we choose? What is it? Is it the same thing? *Is it?* Is it still possible to submit that to the question *what is it?* The way Artaud treats the question of being [*être*] and of beingness [*êtreté*] (his word)[9] will occasionally be open to doubt. Being begins, starting with the *jetée*, not the inverse. We don't even have to speak of pulsion or compulsive interest in the direction of the spurt. The thought of the throwing is the thought of pulsion itself, of the jet of pulsional *force*, of compulsion and expulsion.

Force before form. And I shall try to show that it is Antonin Artaud's *thought* itself. Before any thematics of the spurt, it is *at work* in the corpus of his writings, his painting, his drawings. And from the beginning, indissociable from *cruel* thought, in other words, a thought of *blood*. The first *cruelty* is a spurt of blood. In 1922, "Les Oeuvres et les hommes" (Works and Men): "We have to wash literature off ourselves. We want to be humans before anything else. There are no forms or any form. There is only the gushing forth of life. Life like a spurt of blood, as Claudel puts it so well, speaking of Rimbaud. The mode now is anti-Claudel, and Claudel among us is perhaps the only one who in his good moments doesn't make literature."[10]

The subjectile: itself between two places. It has two situations. As the support of a representation, it's the subject which has become a *gisant*, spread out, stretched out, inert, neutral (*ci-gît*). But if it doesn't fall out like this, if it is not abandoned to this downfall or this dejection, it can still be of interest for itself and not for its representation, for *what* it represents or for the representation it bears. It is then treated otherwise: as that which participates in the forceful throwing or casting, but also as what has to be traversed, pierced, penetrated in order to have done with the screen, that is, the inert support of representation. The subjectile, for example the paper or the canvas, then becomes a membrane; and the *trajectory* of what is thrown upon it should dynamize this skin by perforating it, traversing it, passing through to the other side: "after having exploded the wall of the problem," as he says in "Suppôts et suppliciations" (Fiends and Tortures).[11] I hasten to quote these words and this work so as to insist that we will never hear anything about the subjectile without having the fiend and the torture resound in it. And without reading the pages that bear this title.

The subjectile resists. It has to resist. Sometimes it resists too much, sometimes not enough. It must resist in order to be treated finally as itself and not as the support or the fiend of something else, the surface or the

subservient substratum of a representation. This latter has to be traversed in the direction of the subjectile. But inversely, the subjectile, a screen or support for representation, must be traversed by the projectile. We have to pass beneath the one that is already beneath. Its inert body must not resist too much. If it does, it has to be *mistreated,* violently attacked. We will come to blows with it. The *neither/nor* of the subjectile (*neither* subservient *nor* dominating) situates the place of a *double constraint:* this way it becomes unrepresentable.

Neither object nor subject, neither screen nor projectile, the subjectile can *become* all that, stabilizing itself in a certain form or moving about in another. But the drama of its own becoming always oscillates *between* the intransitivity of *jacere* and the transitivity of *jacere,* in what I will call the *conjecture* of both. In the first case, *jaceo,* I am stretched out, lying down, *gisant,* in my bed, brought down, brought low, without life, I am where I have been *thrown.* This is the situation of the subject or the subjectile: they are *thrown beneath.* In the second case, *jacio,* I throw *something,* a projectile, thus, stones, a firebrand, seed (ejaculated), or dice—or I cast a line. At the same time, and because I have thrown something, I can have lifted it or founded it. *Jacio* can also have this sense: I lay down foundations, I institute by throwing out something. The subjectile does not throw anything, but it has been laid down, even founded. A foundation in its turn, it can thus found, sustain a construction, serve as a support.

Between the two verbs, the intransitivity of *being-thrown* and the transitivity of *throwing,* the difference seems from then on to be as *decisive* as temporary, that is to say, *transitory.* The being-thrown or the being-founded founds in its turn. And I cannot throw [*jeter*] or project [*projeter*] if I have not been thrown myself, at birth.

Everything will play itself out from now on in the critical but precarious difference, unstable and reversible, between these two. Such at least would be our working hypothesis. But what we will surely verify is that,

hypothetically, the subjectile always has the function of a *hypothesis*, it exasperates and keeps you in suspense, it makes you give out of breath by always being *posed beneath*. The hypothesis has the form here of a conjecture, with *two* contradictory motifs in one. Thrown throwing, the subjectile is nothing, however, nothing but a solidified interval *between* above and below, visible and invisible, before and behind, this side and that.

Between laying down and throwing, the subjectile is a figure of the other toward which we should give up projecting anything at all.

The other or a figure of the other?

What does Artaud's drawing or painting *have to do* with such a *figuration* of the other?

Will this figuration accept limits? painting and drawing only, in opposition to the discursive text, even in the theater? Yes and no, yes in fact and up to a certain point, whose arbitrary nature covers over precisely a whole history of a dissociation that Artaud wants to *traverse* like a limit or a wall. But not by rights and rigorously, and this is why I shall propose to give another sense to the word *pictogram* in order to designate this work in which painting—the color, even if it is black—drawing, and writing do not tolerate the wall of any division, neither that of different arts nor that of genres, nor that of supports or substances. The choice of this word pictogram may seem odd. It does not lead back to any supposed primitivity of some immediately representative writing. Certainly, through the magical force sometimes ascribed to a proto-writing upon which we project all the myths of origin, through the efficacity of spells cast or exorcised, the incantatory or conjuring virtues, alchemy, magnetism, such a pictography would have some affinity with Artaud's drawings, paintings, *and* writings. But I shall take it to mean especially the trajectory of what is *literally* understood to cross the border between painting and drawing, drawing and verbal writing, and, still more generally, the arts of space and the others, between space and time. And through the subjectile, the

motion of the motif assures the synergy of the visible and the invisible, in other words theatrical painting, literature, poetry, and music. Without any totalization and taking due account of the subjectilian wall, of this dissociation in the body of which the singularity of the event made into work will always be marked.

We can only speak of this whole pictographic work by insertion and precipitation, by the acceleration of a rhythmical projection and the inscription of a projectile, beyond what we calmly call words and images. Artaud: "These are written drawings, with sentences inserted in the forms so as to precipitate them. I think that here I may have managed something special, as in my books or in the theater."[12] This was at Rodez in 1945, and we will have to take account of a trajectory, in fact that of the subjectile. But as if we were at the end of this trajectory, and in the past ("I think . . . I may have managed"), a sort of destination seems to prevail after the fact. There is "here," on this side [*de ce côté*], that is, drawing, which will be distinguished *on one hand* from literature, from the theater (that is, from sentences). But *on the other hand* these drawings are written drawings that cannot just be put on one side any longer and which—here is "something special"—contain phrases and, even better, sentences that are not only taken in, *stuck, inserted*, but where the insertion itself precipitates the forms. From then on, the analogy sweeps away the limits. What I have managed is certainly special, unique, irreplaceable, inimitable, but singular *like* what I "managed" "in my books or in the theater." Just as in the interior of the "written drawing" the limit has been crossed, the breaking down of the barrier in the other "arts" abolishes the border between *all* these "arts." Everything is singular each time and each time analogical: a figuration of the other.

If in the pictogram the relationship between the verbal writing, the phonogram, the silent line, and color is analogous to what it will have been in literature or in the theater *according* to Artaud, no body, no corpus

is entirely separable. The phrase inserted remains at once inscribed and quivering. It works the charter, the frame of a stubborn spatiality that locks it in [*cadre/carcan*]. The phrase is not *softened*, it no more lets itself be domesticated than it masters the map. It does not lay down the law, it does not enunciate the charter of a constitution. But its protest accelerates a rhythm, imprints intonations, pulls the forms along in a musical or choreographic motion. Without this mobility, the figures would become once more, like the "clear ideas" of the Latin world, "dead and finished." Even if we recognize some of the workings of words, the inserted phrases rise up like enticing themes, trajectories of sound and writing, and not only like propositions. Once they are put forth, they destabilize the proposition, that is, a certain historical relation between the subject, the object, and the subjectile. A relationship of representation. From now on, pictogram will indicate this destabilization made into work.

> *Pictography is to be taken literally here.*

Here: for the reasons I have stated before—the import and the thrownness—*here* means at once *in Artaud* and *according to* Artaud. 1. Pictography *is to be taken* literally. At the moment when the description of the painting gets carried away, crosses the limit, and renounces all its efforts, Artaud lets glossolalia in. Letters transcribe phonemes which seem to belong to no "natural" language; they force the so-called natural language to come back, as if it were losing its senses, toward a state anterior to its birth, toward the in-born of the proposition, of the propositional and representative sentence, of the copula interposed between the *-ject* of the object and the *-ject* of the subject. We will be talking about this copulation again. Letters, then, before the letter, before the letter of words, in an *untranslatable* language. A glossolalia that suspends the *representative* value of language and interrupts the *representative* description of a painting. I suppose that all that will be translated rather well in German, except for the phonogram which is written or drawn here in bold characters:

. . . in the foreground, that enormous mass of earth which, like a musical introduction, seeks to form itself into a frozen wave:

> *o vio profe*
>
> *o vio proto*
>
> *o vio loto*
>
> *o thété*

What is the use of describing a painting by van Gogh! No description attempted by anyone else could be worth the simple alignment of natural objects and hues to which van Gogh gives himself,

> *as great a writer as he was painter, and which gives, in relation to the work described, the impression of the most astounding authenticity.*[13]

Van Gogh was a "great writer" too. To demonstrate that, Artaud quotes some of the painter's letters in which he describes his own paintings, asking the question "What is drawing?" (and not "What is painting?") with words that point out the essential motifs for any scene of the subjectile (the *traversal*, using the word "traverse" twice in seven lines, without counting the word "through" and "working one's way through"; the *"between,"* the *force* of percussion or of projection competing with the more oblique work of "mining" and "filing down": Artaud will speak later of "filing down" the figures in the very stuff of the "subjectile"; finally the *subjectile* itself, if we can put it like that, nonporous because it is of iron, the "wall," the "invisible wall of iron" that has to be traversed, on the other side of representation):

What is drawing? How does one do it? It is the act of working one's way through an invisible wall of iron which seems to lie between what one feels *and what one* can do. *How is one to get through this wall, for it does no good to use force? In my opinion, one must undermine the wall and file one's way through, slowly and with patience.*[14]

This necessity of *understanding* or *hearing* the pictogram is felt everywhere else, for example in a note on surrealist painting in general and in "Mes dessins ne sont pas des dessins . . ." (My Drawings Are Not Drawings . . .). Not only in the form called glossolalia where, as always, a crowd of possible words are stewing under the surface, ready to augment or to repress—in order to do away with it—the so-called natural language. But also in the "I hear": I hear the painters, "like a thread music, like the tetanizing thread of an eyelash-flutter, under the tongue or in the breasts of my buried sexuality," "I hear the stony tam-tam of the ruins of Picasso's beings. . . . I hear Chagall. . . . I hear / I shall always hear. . . ."[15] And as always what he hears about others, he expects to hear of himself: "I mean that there is in my drawings a kind of moral music that I have made in living through my features not just with my hand, but with the gasp of the breath of my tracheal artery, and of the teeth of my chewing."[16] To draw with his mouth, this isn't just giving it his voice, his breath, and his language *before any words,* it is rather attacking the support with these solid, incisive or grinding instruments that are the teeth, it is eating up, sometimes spitting out the subjectile, the "thing," if we can say it like that, as much as its glossomatic body or its phonogram; the word *subjectile* is thus drawn beyond its assigned, normative, reasonable *sense.* It is immediately *unsensed,* incarcerated.

The prophets of old were supposed to speak in tongues, in their glossolalia; it was thought to be immediately accessible to speakers of different languages, universally understandable before any translation at all, as is naively supposed about painting or drawing. From Rodez: "And in 1934, I wrote a whole book in this sense, in a language that was not French but could be read by everyone, of no matter what nationality."[17]

Just a short while ago, this glossolalia seemed to fill in for the absence of any description at the very moment when Artaud was explaining why we have to give up describing the painting, describing in any other

way than that of the writer-painter himself. In fact, this supplement devoted to a "primary emotion" will not take second place, like some auxiliary substitute. Such an evident subordination comes from a historical perversion, which glossolalia opposes in its return to the very place where the work itself surges forth, toward "the generative emotion of the drawing": "and let the onlooker add this primary emotion that nature made secondary, unless he wants to be no more than an incompetent nonreader."[18]

Here true competence belongs to the literality of glossolalia. Besides, in what is improperly called the "commentary" of the drawing entitled *La Maladresse sexuelle de dieu* (The Sexual Awkwardness of God), to which we will return at some length later, it is not in order to palliate the awkwardness of the drawing (treason and translation of the sexual awkwardness of god) that glossemes are suddenly taking up the space. They reveal the original skill of the drawing:

The tomb of everything that has been waiting while god makes a mess
with the instruments he hasn't known how to use at the exact level of his
stomach
Themselves awkwardly drawn so that the eye looking at them will be cast
down.

yo kutemar tonu tardiktra
yo kute drikta anu tedri[19]

The pictograph is also listened to like music. It always resonates *in* Artaud and *according to* Artaud. First of all it is the tone within the language right from the outset of the glosseme. We use the term tone at once for color and for music, between space and time, the visible and the invisible. Its force sweeps away the support, and the tone of a painting has the

power of *evoking,* of summoning—by the voice—what we call, literally and figuratively, a *timbre.*

And so the tone of the last canvas painted by van Gogh—he who, elsewhere, never went beyond painting—evokes the abrupt and barbarous tonal quality of the most moving, passionate, and impassioned Elizabethan drama.[20]

There is probably nothing more constant than this. From his very first texts, Artaud always calls us back to intonation. From what he said of it, in hundreds of places, and whether it is a matter of literature, theater, or pictography in general, I will only pick up on this *motif* which also takes on a value of injunction: intonation must remain in motion, it must be the very act that launches the missile, the force necessary to *traverse* the object when it is an obstacle, a receptacle or a subjectile. The intonation should never become fixed. The sickness lying in wait for it has the inert solidity of a substance: the stubborn and mute resistance of a subjectile, a stabile instead of a mobile. Solidity and hardness always betray intonation, which should on the contrary move and mobilize stroke, gesture, and color, removing the pictograph from the worst theater, "a sort of frozen world, with actors mired down in gestures which will never be of any more use, with *solid intonations* hanging in the air and already collapsing in pieces, with music reduced to a kind of coded enumeration whose signs are already beginning to disappear, with sorts of luminous flashes, themselves solidifed and answering traces of motions."[21]

Throwing, throwing oneself: in words, as in painting, the intonation *projects,* it dynamizes a content, the motion expelling it into a space that is nothing other than the elements of this tonal trajectory, the difference between the projectile and the subjectile, the latter sometimes becoming the target of the former. Artaud says it as early as 1931, in "La Mise en scène et la métaphysique" (Mise-en-Scène and Metaphysics), a lecture at the Sorbonne that deals first of all with painting:

Words themselves have their own potential as sound, they have various ways of being projected *into space, which are called* intonations. *And there is a great deal that could be said about the concrete value of intonation in the theater, about this quality that words have—apart from their concrete meaning—of creating their own music according to the way in which they are uttered, which can even go against that meaning—of creating* beneath language *an undercurrent of impressions, correspondences, analogies . . .*[22]

The following year, a letter to André Gide prescribes a bodily writing, a theatrical hieroglyphics:

The movements, the attitudes, the bodies of the characters will be composed or decomposed like hieroglyphs. This language will pass from one sense organ to another, establishing analogies and unforeseen associations among series of objects, *series of* sounds, *series of* intonations.[23]

The intonation that projects the words beyond their meaning, even into a countermeaning: it is not only in the sounded work that it seems to have its place. Like everything that is projected, it takes and in fact opens space, this "poetry in space" that "first takes on all the means of expression that can be used on the stage, like music, dance, paint, pantomime, mimicry, gesticulation, intonations, architecture, lighting, and decor . . . in our theater which has been living under the exclusive dictatorship of the word, this language of signs and mimicry, this silent pantomime, these attitudes, these gestures in the air, these objective intonations, in short everything I consider as specifically theatrical in the theater . . . carelessly called 'art.'"[24]

We will never grasp the drama of the subjectile without grasping this strategy of the projectile. If pictography is heard both *as* music and *as if it were* music, it is first of all through a certain force of penetration. Just as sound penetrates the ear and the mind, just so the pictographic act strikes

and bombards, perforates, pierces and forces, digs in and traverses. And the adversary against which this force projects itself is the subjectile. From then on pictography becomes, like this music, the principal art by which the theater should be ruled.

"La Mise en scène et la métaphysique" is *exemplary* in this regard. For at least three reasons. *Exemplary,* in the most constant way, as to Artaud's relation to painting, to the theater,[25] to music, and thus to "poetry in space." It is the *same* art, beyond art. Exemplary because this art itself, the same as beyond art, here finds its paradigm in a picture entitled *Lot and His Daughters,* by Lucas van Leyden [see p. 12 above]. *Exemplary* because of the mission that painting sees itself explicitly assigned here: it is to give the *best* example for art, for the whole group of arts to which it belongs, even while it keeps a place apart, within them. But as a supplementary paradox, it keeps this place apart and this exemplary status only insofar as it is an art of hearing. "Even before seeing what is going on, you sense that it is something of great importance, and you might say that the ear is moved at the same time as the eye."[26]

This "at the same time" of the eye and the ear makes, of pictorial art, an art that spills over the limits of painting, "that kind of painting which only knows how to apply paint."[27] The latter expression speaks of a certain *literality* of painting; here it has a negative value that in other places, as we will see, seems to be reversed. But in truth its meaning will have changed. Beyond that secular enclosure of a painting that knows only how to apply paint, pictography, which addresses itself also to the ear, becomes the model of all art, in particular of the theater: "In any case, I submit that this painting is what the theater could be, if the theater knew how to speak the language that belongs to it."[28]

Now, in *this* painting, the one that the theater "should be," and that situates the final destination of art, its address, what guarantees the analogy between the visible and the audible through the projectile of an into-

nation? It is again the breach of a surface or a support, by a "force of destruction" coming from above, hurtling from the sky toward the *under-neath,* toward the *sub*stratum of the surface or of the *sup*port, bombarding it, rending it apart. At once a visible "bombardment" with "solar bombs" and a "resonant rending." We should also pay attention to the living be-ings *born* from this fire from the sky at the moment when it exercises its destructive *force* and *dominates* the landscape. Artaud is describing *Lot and His Daughters:*

Sometimes while we are watching a display of fireworks it happens that, through the nocturnal bombardment *of shooting stars, solar* bombs, *and Roman can-dles, we suddenly see revealed before our eyes in a hallucinatory light, standing out in relief against the darkness, certain details of the landscape: trees, tower, mountains, houses, whose illumination and whose apparition will always remain associated in our minds with the idea of those* ear-splitting sounds. *There is no better way to* express *this* subordination *of the various elements of the landscape to the fire manifested in the sky than to say that although they possess their own light, they still remain like so many muted* echoes *of the fire, like* glowing *points of* reference born *of the fire and put there to permit it to exert its full* force *of destruction.*[29]

The end of the same text reminds us of this power of *intonation, rending* and *destroying* the very thing against which it hurls itself in order to *shake it up* and upon which literally it strikes, like lightning or a thun-derclap. The intonation is a detonation

to make language express *what it does not usually* express. *[I am underlining everything that has to do with* expression, *a word to be understood here in a very prudent fashion, for reasons that will be apparent later.] It is to use it in a new, exceptional, and unaccustomed way, to restore its possibilities for physical* shock,

to divide it and distribute it actively in space, *to use* intonations *in an absolutely concrete manner and to restore their* power *to* tear *as well as really to* manifest *something, to* turn against *language and its basely utilitarian—one might almost say alimentary—sources, against its origins as a trapped animal, and finally, to consider language as* Incantation.[30]

"To tear" and "to manifest" at the same time, to tear or rend in order to manifest, a properly *revealing* gesture against the veil. The rent veil, the truth revealed, the structure of the textile broken into reminds us also of the canvas, a canvas that Artaud was just describing. Not that the incantatory intonation, the nonutilitary language (noncommunicative, nonrepresentative) rends asunder the *subjectile itself* or everything that lies beneath it: for example when the fire of the sky is bombarding a "subordinate" landscape, that is certainly not to be confused with the subjectile. The "subordination" of the landscape, subject and object of the representation, belongs to what is represented *on* the subjectile, underlying the representation. Nevertheless, through a metonymy that precisely organizes the whole scene of the subjectile, the two surfaces are going to be substituted one for the other: in the work of Artaud and under his hand. To attack it as we also attack a subject, we will have to deal with the subjectile *itself*, treating and sometimes mistreating the subject of the representation *under* the subject of representation, violating this underneath of the underneath; and because we have just been witnesses of such a "bombardment," this "tearing" or rending apart whose origin is a "fire manifested in the sky," from which it precipitates its "force of destruction," let us not forget that, some years later, what is thus described *as a painting* and even as the description of fire by the painter will *effectively be produced* in the very stuff of the subjectile itself: Artaud sets fire to it, making holes in the paper here and there with a lighted match. The traces of burning and perforation belong to a work in which it is impossible to distinguish

between the subject of the representation and the support of this subject, in the *layers* of the material, between the upper and the lower, thus between the subject and its outside, the representation and its other. It is really a question of a *destruction*. And to destroy all these limits that structure representation, other "gestures" have to be found and the secret of other "intonations." These words return at the end of "La Mise en scène et la métaphysique," where Artaud reminds us of everything that "condemns us, and with us this state of things in which we live, and which *must be destroyed*, destroyed with care and nastiness, on all levels and in every degree wherever it gets in the way of the free exercise of thought."[31]

But if there is a pictography, it is not just because, literally, a painting *is understood* or heard. 2. Painting is also taken *literally*. In two senses.

1. *First paradox*. Painting has clearly become the paradigm of all the arts, an art plural in itself, if not a total art. In this sense, as we remember, it has to go past "that kind of painting which only knows how to apply paint." And yet, in what seems a contradiction, Artaud requires the painter, in his very excess, to remain a painter, to be satisfied with that. To not use painting with anything else in view beyond itself, to recognize it for what it is with its own means and according to its essence, to the exact extent, so to speak, that this essence is excessive. This essence is an act and an energy. Painting should become what it is, another way of saying that it has to be understood *literally*, in the very energy of its spilling over. Its truth is excessive, like all truth. It is not so much a contradiction as a tension vibrating, for example, in *Van Gogh le suicidé de la société. On one hand*, in fact, this painter knew how to be a painter "and nothing but a painter." Leitmotif: "And so the tone of the last canvas painted by van Gogh—the one who, elsewhere, never went beyond painting . . ."[32] That means, among other things, that he explained himself with his own means and the correct "material" for painting (the subjectile is one of

those): "For van Gogh will prove to have been the most genuine painter of all painters, the only one who did not try to go beyond painting as the strict means of his work and the strict framework of his means."[33]

Only a painter, van Gogh, and nothing more, / no philosophy, no mysticism, no ritual, no psychurgy or liturgy, / no history, no literature or poetry, / these sunflowers of bronzed gold are painted; they are painted as sunflowers and nothing more, but in order to understand a sunflower in nature, one must now go back to van Gogh.[34]

This last sentence (an entire conception of the origin of the work of art as truth, once again Heidegger is not far off) lets us understand that, *on the other hand*, painting does go beyond itself, beyond the painter and his means, crossing *to the other side*, to the other part of the partition, according to the very essence of its truth, the truth of truth, and the truth of nature. For van Gogh will also have been

the only one, moreover, absolutely the only one, who absolutely transcended painting, the inert act of representing nature, in order to make a whirling force, *an element torn right out of the heart, gush forth in this exclusive representation of nature.*

Under the guise of representation *he welded an air and enclosed within it a nerve, things which do not exist in nature, which are of a nature and an air more real than the air and nerve of real nature.*[35]

This excess, the passage *to the other side*, beyond painting that knows only how to paint, *under* and beyond the "exclusive representation," and so on, just in the very moment where there is nothing but painting as painting, remains a disemboweling of a surface, the atomic bombardment and music; and the atoms are literally atoms, that is to say, as with the Greek atomists, figures and letters:

I see, in the instant I am writing these lines, the blood-red face of the painter coming toward me, in a wall of eviscerated sunflowers,

in a formidable conflagration of cinders of opaque hyacinth and of fields of lapis lazuli.

All this amid a seemingly meteoric bombardment of atoms which would appear a particle at a time,

proof that van Gogh conceived his canvases as a painter, of course, and only as a painter, but one who would be

for that very reason

a formidable musician.

Organist of an arrested tempest . . .[36]

Force of the *bomb:* inseparable, these words and motifs are insistent. You might think they were defining *style* itself for Artaud. For example: "the style started off, it went along its way rapidly, and then lo and behold it was suddenly flattened, the sentence was no longer this bomb burst, something in the current was cut off."[37] And as for this opposition of force and form that I was just emphasizing:

The genius of a drawing is not in its art, but in the action of forces that presided over the calculation of forms and signs that the drawn lines leave behind, form, empty out, miss, and that it takes more than just genius to recognize. I am shooting right here on all the spell-casters that I see with my breath and from the bars of bodies in my spell-bound body, for the spell-casters never admit the signs . . .[38]

So the force is not the form, it will never become form; even if, as soon as it is born, form tends to steal force, expropriating it, "seducing and captivating it." You can burn the supports of paper, the papyrus, the parchments, the libraries of the subjectile; you will never destroy the force: "Let the library at Alexandria burn. *Above and outside of the papyrus,*

there are forces: if we are deprived for some time of the faculty of finding these *forces* again, their energy will not be suppressed. And it is good that the too grand facilities disappear, and that *forms* fall into forgetfulness . . . the intensity of *forms* is only there to *seduce and captivate a force* which, in music, inspires a heart-rending range of notes."[39] Much later, in 1945: "Not the colors but the melody that they are calling from one to the other, / *not the forms* but the improbable body they are seeking across the infinite of an arbitrary space. . . . This drawing is then the *search for a body,* a body to hand. " (Like the body, this drawing "could never be identified until now." It was "commented on" in "Dépendre corps—l'amour unique" [Hanged Body—Unique Love].)[40]

I am first of all this force: captured, expropriated, stolen, persecuted, turned away, in search of its body, of a body martyred in the name of god. We have to take the body back from something that still resembles a subjectile, with a face like a subjectile, "the unfathomable abyss of the face, of the inaccessible surface level." I am emphasizing several words in one of the numerous texts of "Suppôts et suppliciations" that have to be quoted in entirety:

Thus it is on the presumption of being god that I have been somewhat martyred everywhere; . . . it's like being convinced of being god and in order to prevent myself from remembering that I have been everywhere assassinated, poisoned, beaten to death, electrocuted; . . . and no matter how pretentious it might be, that is it; . . . for god in his true name is named Artaud, and it's the name of this kind of unnamable thing between the abyss and nothingness, / which has something of the abyss and nothingness, / and that is neither called nor named; / and it appears that it is a body too, / and that Artaud is a body too, / not the idea, but the fact of the body, / and the fact that what is nothingness should be the body, / the unfathomable abyss of the face, of the inaccessible surface level through which the body of the abyss is revealed, . . . the abyss-body; / the Tibetans, the Mongols, the

Afghans listening to god . . . say they have heard the syllables of this sound rising from the abyss:

 AR-TAU

 in which they have always wanted to see the designation of a dark force *but never that of an individual. / But I am this individual. I am, myself, this dark force.*[41]

The persecution of this *force* began the moment I was *born:* "And it is as such a bearer of the nameless abyss that from this side of the time of the world I have been since the fourth of September 1896 in Marseilles [his birth place and date] pursued by innumerable hordes of initiates."[42] Deflection of force, theft, or *substitution* of the newly born, *imposture,* and insinuation of the *instrument.* I have been robbed, not of this or that, but myself robbed of myself, in the very stuff of myself:

And as I was crucified two thousand years ago on Golgotha, in the same way I was poisoned during my existence by the family with whom I lived and which claimed, lying, to have given birth to me. Magic spells and nothing else have made of me this sick man . . . in the neuropathological quest for himself.[43]

 It would certainly be disingenuous to close our eyes, either because of some literary feeling or some absentminded politeness, to what Artaud himself describes as a neuropathological persecution. Moreover, that kind of disingenuousness would be insulting. The man is sick. But precisely, how much more naive would it be *not* to acknowledge this truth: Artaud is telling the truth. Through all the passion or the pathology to which his suffering submits him, his truth exhibits, *in his name,* the truth of the truth, that is to say that every "self" in its own self is *called to* this familial expropriation of the newly born, constituted, properly instructed by that expropriation, that imposture, that forfeit, at the moment when, very

simply, a family declares a child born and gives it its name, in other words, takes it from him. This expropriating appropriation, this legitimation can only be a violence of fiction, it can never be natural or true by its structure. *With everything it entails,* it inaugurates the persecution, in the name of the self, in *my name,* whatever it is, whoever I am. What Artaud describes is true *a priori,* originally, transcendently, let's say rather "from birth." But this truth is a truth of nontruth. So it is not transcendental but always singular, linked to the body of the event and to the event of the body. The body is just that. This nontruth presides over the birth of everything that will be legitimated in language, that is to say in society, under the names of the name, of being, of truth, of me, of god, and so on. Whoever submits, sees himself submitted, *without thinking them in his body,* to these forms and these norms, is well-formed thereby, that is to say, normed: normal. He has changed a force for a form. As such a "normal" subject is submitted to the abnormal norm of this law, the *pathological* passivity of his subjected body resembles that of the subjectile. This is more than an analogy, as we will see. The subjectile, a product of this *congenital* expropriation, is originally cast into unsensedness. Unsensedness doesn't just happen to him. He is driven mad in advance. To drive him mad, from then on, isn't a matter of rendering him insane but rendering him to his madness: unsensed from birth.

What happens between this general structure (untrue truth of truth, nothing of being, me without the self of myself, and so on) and the "case" of Artaud cannot, for reasons of the proper name, correspond to the simple logic of inclusion. We aren't dealing with a particular example in a class. The rising forth, *at birth,* of a proper name and a self defies such a logic. "No matter how pretentious it might be," "god in his true name is named . . ." just like me. It's me. God in his name bears my name and not another. And this has to be true for me to be able to think it. For this name of god to be mine, birth had to be thought of at birth. Myself, in

my body. Only a god can hear what I am saying here. And I can only *do* it, *say* it because I am this dark force.

What is being sketched out here, in this text and in other like texts? How can I be "convinced of being god," after having been "presumptuous about being god"? I am first of all "convinced" *by the other*, accused by him; and, whatever fiction, imposture, or forfeit it conceals, this legal conviction becomes legitimate. This is my conviction and it is true. A patient analysis of the words and the syntax ("in warning about being god, warned about being god, convinced of being god") would reveal the extraordinary, irrefutable and invincible *coup de force*, truly divine, whose feat is linked to a Latinism of language and of law at the moment when the latter sees itself violated in its own name. Such is the scheme: "god in his true name is named Artaud" because you have accused me of it, even "convicted" me. You wanted this, you have charged me with such a mission and I am convicted into it, I have paid the price, all this martyrdom is irreversible, I will make you pay for it. This truth is true by the effect of this performative of imposture I have been submitted to. That is why I am god. But this performative would not have been possible in truth, I would not have been martyred for "two thousand years," on "the presumption of being god [*en prévention d'être dieu*]" (in warning and prevention, through preventive medicine, to keep me from it, but also as a preview and through privation, and still all these words are working under the surface, in preventive detention, like all those committed or detained by common law), I would not have been convinced by you to be god, if I had not first convinced you to convince me, that is, to choose me for such a conviction. And I would not have been chosen if I were not, "myself, this dark force," this individual who now is called AR-TAU.

And above all—this is what matters—the gesture by which such an operation violates a certain superficial naivete of the representative, constative, theoretical discourse unsettles, by its language, any ingenuous way

of relying on the heavily policed discourse of truth or of right. This violent and superbly ironic gesture lays bare the genesis of truth, of the proper name, of rights, of theology, and so on. The apparent sophistication of such a performative ruse is exactly what puts language "to discomfort and to work" in the drawings. It exploits the resources of the idiom that it forces, letting it speak all alone. Whence the burst of sudden laughter. We should be able to hear it even through the lamentations of a tortured being.

The alternative wavers not only between representation and its other, a representative painting and its beyond, but between the inert and what gushes forth, the being-dead of the supine figure and the spurting force, of the projectile or the ejaculation, "to make a whirling force gush forth." This gush (breath, fire, air, sound, intonation, thunder, detonation, bombardment, explosive burst) does not come from an originating being, rather it gives being to being, gives birth, so that being is born from it rather than letting itself be determined or represented by it. It is born in the spurt, the sending up, the launching, the missile or, literally, the missive.

As a consequence of this apparent contradiction and of this vibratory tension: the motif (the motet or the last word of painting according to Artaud) becomes *what exceeds the excessive*:

Painter, nothing but a painter, van Gogh adopted the techniques of pure painting and never went beyond them.

I mean that in order to paint he never went beyond the means that painting offered him.

A stormy sky,

a chalk-white field,

canvases, brushes, his red hair, tubes, his yellow hand, his easel . . .[44]

All the heterogeneous categories of "means" are deliberately associated in the same series, and they are means of "pure painting": the thing to represent, the sky and the plain just as much as the body of the artist and the material, that is, the place from which painting spurts forth (the tubes) but also these two supports or receptacles of the spurt projected forth, the "canvases" and this support of the support which is an easel. As for the color ready to spurt forth, *expressed*, from the tube, it guarantees in writing a metonymic passage between the red of the hair and the hairs of the brush, between the brushes and the yellow of "his hand," between the body proper and the instrument of the artist. By simple contiguity: "canvases, brushes, his red hair, tubes, his yellow hand, his easel." As for the two things to represent, their choice reproduces the scene we have already recognized: the top and the bottom, the top from which the ground is bombarded and the substratum, the support, the subjectile at once flat and massive, in this case the plain ("A stormy sky, / a chalk-white field, / canvases . . ."). A contiguity again effacing the limit between the "plain," as object or subject of the representation, and the "canvases," the subjectile.

The motif, we were saying, the excessive exceeded. On the same page:

One day for no reason he decided not to go beyond the subject,

but after one has seen van Gogh, one can no longer believe that there is anything more impossible than to go beyond the subject.

The simple subject of a lighted candle on a straw-bottomed chair with a violet frame says more in the hands of van Gogh than all the Greek tragedies. . . .

It is literally true that I saw the face of van Gogh, red with blood in the explosion of his landscapes, coming toward me,

kohan

taver

tensur

purtan

in a conflagration,

in a bombardment,

in an explosion,

avengers of that millstone which poor mad van Gogh wore around his neck all his life.

The millstone of painting . . .[45]

The bombardment again, the projectile. As for the millstone, we will find it later, in the subjectile itself.

The excessive exceeded, the passage toward the other side in the very moment when the thing is presented "to us, in front of the fixed canvas," this is not a dialectical contradiction, it is the amazing thing, the marvelous force of the "born painters" who know something about "prenatal suffering":

Van Gogh renounced storytelling in his painting, but the amazing thing is that this painter who is only a painter,

and who is more of a painter than other painters, since he is the one for whom the material, painting itself, is of primary importance,

with the color caught just as it is when squeezed out of the tube,

with the impress of the separate hairs of the brush in the paint . . .

the amazing thing is that this painter who is nothing but a painter is also, of all born painters, the one most likely to make us forget that we are in the presence of painting,

painting intended to represent the subject he has selected,

and who presents to us in front of the fixed canvas the enigma pure, the pure enigma of the tortured flower. . . .

Why do the paintings of van Gogh give me this impression of being seen as if from the other side of the grave . . .[46]

Let's stop telling stories. We will demonstrate that a subjectile has no story, no history.

2. *Another paradox.* If painting is understood *literally*, it forces the subjectile *with letters*. Let us reread, for example, the page that I just interrupted in the middle. In van Gogh, painting has a "place of primary importance" with "color," with the "impress" of the hairs of the brush, with the "touch of the paint itself," and so on, but also "with the *i*, the comma, the tip of the point of the brush itself twisted right into the paint, applied roughly, and splashing in sparks." A formation of the letter in a drawing that takes it away from the word, from the verbality of articulated language whose pure sonority nevertheless spurts forth in the subjectile. At the extreme, this literalization tends to annul the support in the very dance. The latter would become the picto-choreography of a grammar without a subject or object, in other words, without a subjectile. The body itself, finally itself, assumes literally its letteral fate. All the altercations with the subjectile tend toward that limit. For choreographic grammar to *take place*, as with the Tarahumaras, the body must reappropriate itself, take itself back from god who expropriated it during a real assassination that was also an abortion. The body must literally be reborn ("this drawing is then the search of a body," in "Dépendre corps—l'amour unique").[47] Such a birth is the unique event. It takes place once. Against the theological expropriation, the one that will have given way to the subjectile, to the organic, underlying, supine, dead, material body-subject. For the second paradox resides in this: we have to find again, in pictography, a certain literality of the matter that does not go beyond painting in its material, but we have also, a double constraint, a double conjecture, to immaterialize this matter, exactly the one that makes a tomb of the subjectile. Matter that has become volatile will give birth to this drawing of a literal and numbered choreography:

For Ciguri, *they say, was MAN, MAN such as FROM HIMSELF, HIMSELF in space. HE constructed HIMSELF when God assassinated him.*

That is exactly what happened. . . .

For I thought I saw in this Dance the point when the universal unconsciousness is sick . . . upon certain hasty blows struck by the Priest who was now holding his cane with both hands they came forward rhythmically one toward the other, with their elbows spread out and their joined hands making two triangles coming to life. And at the same time their feet were drawing on the ground circles, and something like the parts of a letter, an S, a U, a J, a V. Numbers in which the form 8 came back most often.[48]

Just one example among so many: this choreography moves to a sort of reappropriation of the subjectile. The Body proper becomes the living subjectile, drawing and writing. It is the letter in motion. "Letter without letter, / word without word."[49] It no longer has to *support* the letter, no longer suffers it. What has disappeared in the dance is the other subjectile, the inert receptacle, the exteriority of dead matter, the epigraph, that technical and parergonal supplement foreign to the work.

Such was the *choreographic* motif. There is also the *chromographic* motif: colors and letters travel from one to the other. During this traverse, the resonance of a word guarantees the metonymic transition. Let's take for example the bellowing of red, the intense rumbling, the symbolic vehemence of a color. We have seen the artist's hair and the hairs of his brush *reddening* with a single fire, like the burning of a single body. It was van Gogh, it happened wordlessly in a way, and it was a matter of the body. Here is the incubation of the red spirit, the *red* soul, it speaks and it "bellows":

The painting of María Izquierdo proves that the red spirit is not dead: that its sap is boiling with an intensity exacerbated by the long travail of waiting, of incubation, of maceration.

The red soul is concrete, and it speaks. We can even say without exaggeration that it bellows.[50]

Again a propos of María Izquierdo, Artaud speaks of "the mystery *born* of color." This unites with the "vibration" of the solar spectrum, it "is torn apart even unto the music where it *came from*."[51] The correspondence of red and blue makes this manifest, as if in an *exorcism* which we have to recognize in such a painting.

Another stratum of the hieroglyph represents the word somehow "folded in," as Artaud says of his own drawings, within a graphic whole: "We know the hieroglyphic procedure of the Indians which consists in placing before the mouth of an orator or a singer the imaginary sign of the voice, of the word." The example he chooses is that of another painting of María Izquierdo that uses the smoke of a nearby factory, this European sign, to represent by these "spiral wreaths" the "respiration, the animated breath" of a singer. But Artaud "infinitely prefers the canvases where no trace of the European spirit is found."[52]

No matter how we *understand* it, this literalization resembles a stratagem, rather a counterstratagem. In a testing of strength, it frustrates the authority, the independence, and the exteriority of the subjectile, really its treason *as to the truth*. If once "what is called the subjectile betrayed me," it is because it can always *betray the truth, either* by revealing it, *or* by hiding it.

This traitor represents death: the supine body, of course, the inertia of a material support supposed to represent the dead person but also the cadaver or the specter of a being assassinated, now gifted with an evil power, which every resentment animates. This is a foreign subject, a reactive object, inassimilable and poisoned. Everything still to be said or done against the subject and against the object first aims to conjure up the spirit crying vengeance and which lets itself be *represented*, in all the senses of

the term, by a subjectile. A curse, a representation of vengeance and a vengeance of representation.

How should we think of *this* representation? And first of all, representation in general for Artaud?

One of the primary conduits leads through the word or the category of *expression*. The place of a singular maneuver. In an unsettling arrangement, Artaud seems always to have given it credit, perhaps disconcerting for us now. The expression, let's say, the representation of the inside in an outside, isn't this the most conventional and idealized concept of all, absolutely threadbare? But watch what this word becomes in Artaud's handling, possibly expressing something else. For in his eyes, right up until the last texts, expression remains the truth of the pictography, "in the last analysis" its "profound truth": "It's perfectly clear, in the last analysis, it's the expression that is valuable in a painting. By expression I don't mean a look of laughter or tears, rather the profound truth of art. The equivalent of a new reality, taking certain lines, a certain brushstroke."[53] That was in 1921, under the title "L'Expression aux Indépendants" (Expression at the Independent Exhibition). In 1924, Artaud says he is disappointed by Picasso who "defines himself much more than he expresses himself."[54] In 1929, "a certain unevenness of expression" in "a certain painting" seems to betray "a sickness of thought."[55] But already expression no longer meant a relation of the subject to the object. The word designated the production of a "new reality," its violent coming to be, its *expulsion at birth*, by the act of birth. A birth *expresses* certainty by bringing to the daylight and outside what has been carried to term and inside, but at the same time the reality that it expels, the work, the excrement, the child, has, so to speak, no past. It is in-born before birth. The operation of this putting in the world, the expression, always breaks into a subjectile, the body of birthing and touching for this new body, "according to a certain rubbing of the brush." If such an *expression* constitutes the "ideal of the

artist," this ideal no longer resides in the representative space of a relation between the subject and the object. It forces matter, and thus the subjectile, beyond this opposition: "It's also expression that confers on the schemes of Foujita a rarefied, almost spiritual air. . . . The subject is not of importance, nor the object. What matters is the expression, not the expression of the object, but of a certain ideal of the artist."[56] This expression centers the whole "L'Automate personnel" (The Personal Automaton) which itself concentrates in a few pages,[57] a pretended description of a painting, everything we are trying to analyze here, and I am not just thinking about the "sex taut and blown up like an object," or about the launching of the missile ("toward those organs whose sexuality is increased, which eternal sexuality is catching up with, is directed a volley of arrows shot from below the canvas"),[58] about the traversal of the subjectilian division, canvas, veil, paper, wall, and so on, to see the tearing itself ("If we could pass behind the wall, what a tearing apart we would see. . . . The high-rise wall of experience does not make me swerve from my essential delectation"), or of the rending force of the fire, of a fire from the heavens ("the irritating force of a fire lacerates the interior firmament, the ripping open of intelligence"). The "purest expression" is precisely the manifestation of these forces.

Unsensed from birth, forcing birth to birth, expression does not describe the movement by which what was already inside lets itself be translated, transported, transposed outside, represented or exhibited upon the canvas, a sort of screen upon which images would project themeselves. The screen must be traversed by an expression that attacks the subjectile, hurls its projectiles against it, bombarding it until it bleeds, sets it on fire, and perforates it. Cruelty is always unleashed *upon a subjectile*. And upon all the history that piles up in its thickness without thickness, introjecting and interjecting itself between the two epidermal surfaces of a membrane worth nothing in itself except as it is interposed. And this intercessor

sometimes *betrays*. It shows itself the stronger. Its indecisive otherness pro-
vokes awkwardness. We no longer know who we are dealing with and to
whom we are speaking.

Now we should try to understand Artaud when he at once alleges
and denies his so-called awkwardness, a certain technical clumsiness in
his drawing. We wouldn't grasp anything if we didn't start from the *experi-
ment* of the subjectile: the latter, as we know, betrays. Now an awkward-
ness always *signifies* something; and it signifies this betrayal rather than a
technical weakness. It's a sort of lapsus, a failing at the moment when the
device of the subjectile, a sort of trap, constrains the drawing hand. Ar-
taud's technical formation was incontestable, it breaks through in all his
work, even including certain Rodez drawings. The awkwardness, that lack
of address Artaud talks endlessly about, has meaning only in the alterca-
tion with the subjectile and the forces it gathers in itself, that it *supposes*—
so goes the working hypothesis—under the surface between the surfaces
of the subject or the object, offering a stubborn and clever resistance to
the hand. It detours the hand toward the wrong destination, sending it
literally to the wrong *address,* if I can put it like that.

The awkwardness then comes from another source, and is submitted
to. Artaud means to reappropriate this hand and this body against what
he calls "the drawing principle," that is, against the strict organization
of that kind of know-how which regulates itself by foreign forces and
compromises with them. This compromise is the system of the beaux-
arts, its technique, its norms and departments, its devices. The subjectile
is one of them, but at the same time it represents and adjusts them to
each other within the framework of the canvas. The mastery of the person
drawing subjected to the "principle of drawing" testifies to the history of
a dispossession and a deflection. The address is a lack of address or an
awkwardness, and the counter-awkwardness of Artaud is really making
two gestures at the same time: it speaks of the wrongdoing and tends to

correct it, falls into a lapsus, pays the price of treason *and* makes up for the wrong, tries to scratch out the dispossession. A good awkwardness would then consist of unlearning the "drawing principle," ridding oneself of a nature too tractable with respect to norms only in existence because of a default. This is a whole other memory and another knowledge, another school entirely:

This drawing, like all my others, is not that of a man who doesn't know how to draw, but of a man who has abandoned the principle of drawing and who wants to draw at his age, my age, as if he had never learned anything by principle, law, or art, but only by the experience of work, and I should say not instantaneous but instant, I mean immediately deserved. *Deserved in relation to all the forces that in time and space are opposed to the manual work of creation, and not only manual but nervous and physical.*

 That is, against the taking mental possession of the soul, and its restoration in the being of reality.[59]

If he "abandoned" the "principle of drawing" like that, then he must once have had it at his disposition. And as the drawing principle supposes the "taking possession," the subjection to malevolent forces, the only way to dispose of the drawing principle is to put oneself passively at its disposition—and this is the normal cleverness of the draftsman. Cleverness lets itself be had. So Artaud abandons the drawing principle because he has first "despaired" of it. And the "wrongdoing" he then condemns would not just pervert a manual skill, an ability to draw lines. It would have tampered with our body, our eyes, and the limits of our vision, the "principle of our cranial box" (which commands the "principle of drawing"), our organic constitution in its general architecture. However strange and localized it seems, the appearance of the word *forceps* in "Mes dessins ne sont pas des dessins . . ." illuminates, right in the track of those

metonyms that strengthen this writing, the allusion to an obstetrical violence. If our vision has been *"deformed,* repressed, oppressed, set back, and suffocated by a certain wrongdoing," some crime must have taken place very close to the birth. An evil force must have set upon the newborn:

> *My drawings are not drawings but documents,*
>
> *they have to be seen and what is* in *them has to be understood,*
>
> *if they were being judged just from the artistic or lifelike point of view, as an object speaking and successful, you would say: that is very bold, but it lacks manual skill and technical formation and Mr. Artaud as a draftsman is still just a beginner, it will take him ten years of personal apprenticeship or in the polytechnics of the beaux-arts.*
>
> *Which is false because I worked* ten *years on drawing during my entire existence*
>
> *but I despaired of pure drawing. . . . We have a mote in our eye from the fact that our present ocular vision is* deformed, *repressed oppressed, set back, and suffocated by a certain wrongdoing on the principle of our cranial box, as on the dental architecture of our being, from the coccyx at the base of the vertebrae to the place of the forceps sustaining the brain.*
>
> *Struggling against this wrongdoing, I have pointed up and polished all the angers of my struggle, in the light of a certain number of totems of beings, and there remain these miseries, my drawings.*[60]

No technical lack, then, in the failure of pure drawing, only a hand-to-hand fight where a sort of *abortion* at once repeats and counterfeits itself, in self-imitation by simulacrum, controlling itself and contradicting itself through a kind of formal argument toward another birth, that of an expression. For example:

The drawings I want to speak of are full of larval forms, in the very stubbing of the pencil stroke against the paper, and I wanted them to agree between themselves so that with the colors, the shadows, and all their reinforcements, the whole would be valid and singular.[61]

The subjectile, place of treason, always resembles a device of abortion, it gives rise to a deflection first deforming by precipitation and causing a headfirst fall ("stubbing"). A premature fall, lapsus, prolapsus, expression, excrement, a newborn supplanted, deformed and detoured, mad from birth from then on, made with the desire to be reborn, and that you can read in the lines, not in the color. Treason affects the drawing principle. Color seems intact and innocent.

So the question of Artaud is not a question of technique. Or rather yes, it's a question of technique insofar as it does not belong from birth (better say birth here than origin) to the order of technique—nor even, consequently, of art. But this question, Artaud doesn't ask it, he experiences it—traverse, violence, torture, torment, passion, agony—at the moment when such a *putting to the question* amounts to a crime. And this question isn't that of technique or of art unless you go back further, toward the untellable history that was able to give way to what we call the art of drawing, the technical savoir-faire—let's say in this case *adroitness* [*addresse*], a word in which we will also hear the sound of destination.

No more than adroitness, maladroitness or awkwardness [*maladresse*] is not restricted to the sphere of a technical evaluation. Besides, very early, from 1921, Artaud only praises a painting if its "character" puts it "above any technical question."[62] And much later, maladroitness, at least such as Artaud pretends to vindicate, becomes, against the "principle of drawing," a kind of backward skill, the apostrophe that knows skillfully how to address itself, turning away from the supposed receiver to the one it wants to insult, condemn, reject, send away: Shit! you are shit *and* you

only deserve shit, *in a word* dejection, that I hurl in your face, that I throw toward you like a projectile, like some objection as short as an interjection,[63] scarcely a word. This projectile is my drawing: maladroit but adroit, taking good aim, correctly adjusted to the good address of its true destination:

> *. . . you will realize*
> *from my maladroit drawings,*
> *but so crafty,*
> *and so adroit,*
> *that say SHIT to this world.*
>
> *What are they?*
> *What do they mean?*
>
> *The innate totem of man.*
>
> *The amulet to come back to man*
>
> *All the breaths in the dugout curvature*
> *hollow*
> *pesti-ferous*
> *of my real teeth.*
>
> *Not one that isn't a breath cast out with all the strength . . .*[64]

The awkwardness is *destined:* to do violence to all the fiends. Once the subjectile has become the solid shelter of all the fiends and kinds of succubus that haunt it, awkwardness takes up arms against it. Man must be ripped away from these malevolent powers he remains subject to, he has to "come back to man" and must make a special *spell* for that.

Even "on the page." The maladroitness used to cast a spell ("the amulet to come back to man") knows perfectly well where to come and to whom to come back, it plays its address, its adroit maladroitness against the opposing maladroitness. The name of the adversary is god. "Awkwardness" could be read as a synonym or a pseudonym, one of the names of god. Many names in one. First of all, of course, the inexperience and the awkwardness of the one who does badly what he does. He won't have succeeded in his work, all that is to *take up again*, to take back from him, for, secondly, the maladroitness of god not only impels him to do the bad, it impels him to misdoing or to wrongdoing: there he gets along and his address is the address of the bad; then, as his wrongdoing consists in a detour from the proper destination, the address of the bad is understood in the name of awkwardness [*maladresse*]. But that isn't all, nor is it perhaps the essential thing, for all these cases of maladroitness reveal the male. As a male, god doesn't get it up right, he doesn't stiffen correctly, his erection is faulty, it is at fault, it screws around with itself. *La Maladresse sexuelle de dieu*, 1946, explains in short the awkwardness of the drawing, it is the cause of it, it prints it or is printed in the subjectile itself, on the page. The black pencil goes to pains to *bear witness to* this maladroitness in fixing it up. It is at the same time a correction inflicted on god to make him fall. Co-erection and detumescence. No more than its title, the "commentary" doesn't let itself be separated from the work. It speaks of the couple, in a sense of the two maladroitnesses, that of god and that of the drawing:

> *This drawing is willingly thrown together, thrown on the page as if it despised any forms or strokes, so as to scorn the idea taken up, arranging to let it drop.*
> *The maladroit idea of god purposely standing not straight up on the page*
> *but with a distribution and flashes of colors and forms enlivening this awkwardness,*

witness the head high like an egg scarcely sketched and beards radiant with
hair that could have been just a hasty sketch in a drawing much more polished,
but whose hasty trace I wanted to keep at the summit of this red puppet,

 like a stain that will spread out on the clothes and weigh heavy on the
peepee organ.[65]

All that, let's take notice, is still *thrown* [*jeté*] ("thrown on the page").
It would be just an expression in current use, to say a "hasty sketch," if
the jet or ejaculation, the bombardment and the aggressive projectiles,
did not form once again the major motivation of the pictorgram (drawing
and "commentary"). And these projections attack or pierce the walls. The
weapon can be the phallus or the gun ("the soul that wanted to go to bed
with its father, / sleep mounted as you mount the virgin phallus, / gun
root of the electric night, / gun to pierce the misery, the illustrious story /
of believing in god, / when I am the one doing it, / says the soul, / when
I ejaculate this shit-filled fart . . ."). The projectile is often the fart, the gas,
that is, the spirit: *gheiss, Geist* ("Will this soul find eternal rest, against the
internal gas of the spirit of jealousy from which men have burped up
god"). And this fart becomes once more the bomb from on high, but
here I would be the surface exposed, a sort of subjectile openly offering
its "walls." So as no longer to be the subjectile of god who comes to
"fart" his spirit on me, and whose gas emanates from a retinue or a consti-
pated holding back ("shit-filled" means "soiled with excrement"), I chal-
lenge him:

 And I say that my soul is myself and that if it pleases me to make a daughter
who wants to bed down on me some day,
 shit and pee on me,
 I will make her toward and against god the spirit of retention shitmaker
ceaselessly farting on me, eject like a bomb with her paradise upon the walls of the
niche of my skull, where he has encrusted his nest.[66]

Just as everything is here "thrown on the page," the bombardments of the spirit (the farts of god, the weapon and projectile of this great mal-adroit) project the gas or excrement toward the surface of a here-below (*bed, bed down, go to bed, paradise, wall, niche, nest,* and so on), of a tomb or a gravestone toward which you fall [*tomber*], unless it falls from him:

> *The tomb of everything waiting while god makes mistakes*
> *with the tools he hasn't been able to use level with his stomach.*
> *Themselves awkwardly drawn so that the eye that sees them will collapse.*
> . . .
> *While you fart in your clouds, impotent spirit, issued from the tomb of my*
> buttocks,
> . . .
> *turn the box of the angel around in my doubly*
> *cracking tomb.* [67]

Although the awkwardness of the drawing "deliberately thrown together" reflects or attests to the sexual awkwardness of god, *the work takes place*, not the disaster, nor the simple fall, absolute failure, or death. Something will have been redressed (a wrong, really) and stood erect, a kind of taut equilibrium will have compensated, supplemented, repaired the instrumental awkwardness (that of the sexual instruments god hasn't been able to use "level with his stomach"). And what I shall hesitate, for obvious reasons, to name the salvation of the work, the rescue by work, the survival of the newborn in spite of the malformations, would come to him perhaps as much from color as from lines, in any case from a happy composition, a good distribution, some consonance of colors and forms that "permit this misformation to live." This is the "but," "the mal-adroit idea . . . but":

*The maladroit idea of god purposely standing not straight up on the page
but with a distribution and flashes of colors and forms enlivening this awk-
wardness . . .*[68]

The subjectile is the place of this explanation, *Auseinandersetzung* or
altercation with the sexual maladroitness of god. At once a place of com-
bat, the meadow for a duel, a ground, a bed, a bedding down, even a
tomb: you give birth there, you abort there, or you die there. Birth and
death, the origin or abortion can be simultaneous there. It isn't enough
to say that a subjectile is stretched or lies out *beneath*. War takes place
between several *underneaths*. The parergonal support of the work, the sub-
jectile sustains also the whole system of a culture marked by evil, by the
sexual maladroitness of god that requires the expulsion of a *parergon*, the
installation of an exteriority outside of sense, unsensed [*forsené*], of a ma-
terial substratum supposed by representation. But the bed of this supposi-
tion, the place of the excrement or the fart, of the projectile or, inversely,
of the abusive suppository, lets itself be inhabited by the fiends and all
the succubi. As subject and as object, the maddened subjectile betrays the
hardened, inert, chilled effort of the subjection to the maladroitness of
god. But under it, and for this you have to perforate it, put it to trial, not
sparing it as something outside, hors d'oeuvre, under it once it is perfora-
ted, you could have the innate "come back," "come back to man." With
thunder and destruction, lightning, bombs, projectiles, you can blow
away the old subject.

All that "on the page" or, the expression comes back even stronger
a year later, "on the paper": at least four times at the beginning of "Dix
ans que le langage est parti . . ." (Ten Years Ago Language Left . . .). And
each time it is to speak of the "stroke," the "pencil strokes" that come
breaking into the surface, but also the "breath" that implodes in the
whole text like the aspiration of an interior lightning. *Lightning* again:

Ten years ago language left,
and in its place there came
this atmospheric thunder,
 this lightning

 . . .

I say then that language distanced is a lightning that I brought on now in
 the human fact of breathing, sanctioned by my pencil strokes upon
 the paper.

Then the stroke:

How?
By a stroke
 anti-logical
 anti-philosophic
 anti-intellectual
 anti-dialectic
 of the tongue
by stubbing with my black pencil
 and that's all.

The breath: a "breath *cast out*" in the grammar of the verb (I breathe) or of the noun (the breath), whether it is my attribute or that of the machine: the "machine that breathes," "that also breathes" and "for ten years with my breath / I have been breathing forms hard, / compact," "all the breaths in the dugout curvature," "Not one that isn't a breath cast out with all the strength / of my lungs."

The breath breathes in the pictogram, and literally breathes into it, imprinting rhythm and music. It understands and helps understand, "to understand the corrosive structure, / I say understand / the constructive

structure, / where the drawing . . .". Of what is understood through the pictogram, of its breath, even the visible image is only a worn-out exhausted simulacrum: the "image on the paper is no longer that world but a decal, a sort of diminished / copy."

This hierarchy of the audible and the visible seems to reconstitute some classic schemas; but it does not relate word or language to the "image on the paper." Breath does not mingle with voice, in any case not with the voice of language or of discourse, of the expression or the word:

> . . . *this was first a machine that also breathes.*
> *It's the search for a lost world*
> *and one that no human language integrates*
> *and whose image on the paper is no longer that world but a decal, a sort*
> *of diminished*
> *copy.*
> *For the true work is in the clouds.*
> *Words, no,*
> *arid patches of a breath fully breathed . . .*

Breath lends *understanding* in the pictogram but *crosswise*, in crossing both *words* (glossolalia, for instance, beyond any representative discourse, beyond any verbal units: what "no human language integrates") *and the page*, perforating the subjectile that both of them are. It is too obvious for the paper, but we were suggesting it before, the word itself can become subjectile. It can permit itself to be treated like that: *subjectile, then, is a word*. Sufficiently subjected so that, understood now as an adjective, now as a noun, it forms a completely different sentence. But both are true.

So a pictogram breathed out crosses the subjectile: the sending of a projectile, a drilling, a piercing through. A passage beyond representation and the meaning in it: necessarily by making a hole:

> *. . . I say understand*
> *the constructive structure*
> *where the drawing*
> *point by point*
> *is only the restitution of a drilling,*
> *of the advance of a drill in the lower depths of a latent sempiternal body.*
> *But what logomachy, isn't that it,*
> *couldn't you, Mr. Artaud, make your lantern a bit brighter?*
> *My lantern?*
> *I say*
> *that for ten years with my breath . . .*

Necessity of a *logomachy.* That is to say beyond the becalmed polite-ness of a cultured language, the war with words, the drilling and mad-dened destruction of a language policing and reigning over its subjectiles. In this conflagration of words, against words, the guardians of language will denounce a logomachy; they will require that discourse conform to pedagogy and philosophy, indeed to dialectic. But logomachy aims at taking breath back from them, in a war of reconquest. The motif of *res-titution,* which appears at least twice in this same passage, does not neces-sarily have the calming sense that one might imagine: the reconstitution of a past, the reconstruction or reintegration of a body, the reerection, resurrection, and so on. "The search for a lost world" doesn't chase after a human past, a golden age that, albeit in its mythic dimension, would have had some form of a past presence. The "maladroit drawings but . . . so adroit, that say SHIT to this world," they don't oppose to it a "lost world" toward which we would have to return by crossing the veil or the canvas. Restitution never has *simply* the form of a return, of a reintegra-tion, a resurrection. First of all the drawing does not restitute something, but the having-taken-place of a *drilling* ("where the drawing / point by

point / is only the restitution of a drilling". . . "the attempt on the verge of a pierced infinite"). And this piercing through, this drilling that also exposes to the daylight, promises less the reappropriation of a object lost in the past than a new birth to come. Renaissance, of course, but then with all the perforation of what will have been forcibly in-born, that is to say, *without past* will be born. And then, beyond this same grammar—grammar is always the order of subjectilized words—*without a future perfect.* If at least we understand under these words some modifications of the present (the past present, the past future anterior), *that is* of the object, of the subject, and of the subjectile, of presentation and representation.

These works no longer belong to Art if the latter always implies representation, reappropriation, reintegration, transposition, or figurative translation of the same, as implied by the latent affirmation of "Dix ans que le langage est parti . . .". Neither Art, then, nor Drawing, nothing that rests, with such a title, *on a subjectile*, "on a paper":

> *Now what I am drawing*
> *these are no longer themes of Art transposed from the imagination*
> * onto the paper, these are not affecting figures*
> . . .
> *no drawing made on paper is a drawing, the reintegration of a*
> * sensitivity misled . . .*

If the restitution no longer corresponds to a movement of intimate reappropriation, at least not directly, it's because in its "proper" moment, if we can still put it like that, its *expression* has the excremental violence of a new writing of the body that perforates the surface and attacks the subject: all the spurtings quieted, inert, deadened, supposed, posited, all the supports and substrata that give to the subjectile its stubborn objectivity, all the effects of the sexual awkwardness of god. For this expression,

the best-formed instrument is excrement: an insulting projectile, conjuration, exorcism, incantation, imprecation, exclamation hurled against the malady, catharsis, and amulet.

For the man is very sick. And he also diagnoses:

Now what I am drawing

. . .

these are gestures, a word, a grammar, an arithmetic, a whole Kabbala
* and which shits at the other, which shits on the other,*

. . .

you will realize
from my maladroit drawings,
but so crafty,
and so adroit,
that say SHIT to this world.

To *throw* something right in someone's face, like an insult frank and straight and direct, addressed to this world with no detour, to spit at that face the figure of *excrement*, in a word, shit, that sums it all up: gestures, grammar, arithmetic, and the Kabbala that shits *at* the other and *on* the other. The crafty person, who comes to correct some wrong, is a sort of copula between the right of the *adroit* and the right of the awkward. The drawings are awkward because they are crafty, skillful, sly, adroit, indirect stratagems for plaguing this world with its norms and values, its expectations, its Art, its police, its psychiatry: in a word, its *rights*. Artaud is speaking to these sick rights to force them to say shit and saying it to those rights. *To* these rights, and *at* them, casting out the very word like excrement as well as excrement as a word. There would be a lot to say about the notions of address and law and rights, precisely, and the directions of the *throw* or the spurt [*le jet*], of the rejection [*le rejet*], the dejection, and

the excrement. You can cast or spurt in all directions, whether with a projectile weapon or to send some gift, even some help. But sometimes it's enough to say "cast" or "throw" [*jeter*] in order to suggest the connotation of the cast or thrown away [*le déchet*] as it is rejected or abandoned. Usually, I throw on the floor anything that seems to me without value, or shoddy. But excrement, a perfectly shaped model of what is thus rejected downward, can also be of value as a weapon or as a present. And it can be thrown *upon* as well as *at*. At the other or upon the other. What receives excrement like that, for example right in the face [*la figure*] of its name, could be the surface of an underlying body, a subjectile in general, but we should also note that the subjectile was constituted in this world and in the traditional history of its Art as an excrement itself: what doesn't belong to the body of the *work* is found beneath it, an epigraph, a matter exterior and parergonal sometimes dropped.

Whence the crafty outlook and the torment of the scene. We say shit to the subjectile, to this world as a subjectile or as the place of subjectiles in general. But we do it in casting at it some subjectile, or what, *in this case,* can always become such.

Now what happens when excrement becomes breath, when in a word it expresses itself thus, *shit,* throwing itself against the subjectile without describing anything else, without representing anything more than itself?

This language is no longer a language. It should at least no longer sublimate itself or make itself subtle toward some sense or some object. It should *express itself* without delay, without relay, without tardiness. In the bodily struggle where a breath throws itself against the subjectile, it makes itself *literal* and *material.* But the letter then is no longer subjected to the spirit and matter is no longer interpreted as a *subject* (substratum, substance, support, *hypokeimenon,* subjectile). A literal matter beyond transposition, translation, figuration, rhetoric. We were saying

before how a pictogram, *this one*, should be understood *literally*. It was necessary to make it precise: to the letter of an emancipated letter, of a letter that, even in words, even in verbal language, no longer obeys the conventional law of meaning, of reference, of representation. Artaud calls the letter subjected to this law simply the "written letter"; he opposes it to the "letter" as such. He does not propose to abandon words, sentences, nor the letters that are caught up in them. But he means to bend them to a new relation, a new "comportment," a new destination, and it takes strength: let the letter traverse and work through the subjectile, doing it literally, that is to say without any submission to writing in the current sense, to the "human tongue," to literature itself:

> *Not one that isn't a breath cast out with all the strength*
> *of my lungs,*
> *of all the target*
> *of my breathing,*
>
> *not one that doesn't answer to some real bodily act,*
> *that isn't,*
> *not the figurative translation*
> *but something like the efficacious target,*
> *on the* materialized *paper.*
> *I am, it seems, a* writer.
> *But what do I write?*
> *I compose sentences.*
> *With no subject, verb, attribute, or complement.*
>
> *I have learned words,*
> *They have taught me things.*
> *In my turn I teach them a new way to act.*

Let the pummel of your tuve patin
intrumen you to a bivilt red ani
to the lumestin of the sectioned utrin.
That means maybe that the woman's uterus turns to red, when van Gogh
 the mad protestor of man tries to find their
march to stars of too proud a fate.
And that means that it is time for a writer to close up shop, and leave the
 written letter for the letter.[69]

That happens. It's happened.

This machinery of the breath has *always* been at work. Certainly, and from the first texts. But this *always* has not always expressed what it had to be with the same force. And it isn't only a question of degree. This force is born one day, to itself, from a certain ripping apart. *Once, one time only, at once,* even if in another way it was already there, innate although in-born.

What had kept it so distanced from itself? Precisely a difference of substance or of support, what separates "the written letter" from the "letter" as such, differentiating between literary art and the literal drawing. For such an event to take place, for the distance to be reduced, a *departure from language* was necessary, a separating from language separated from the body, moving away from a language of words without space or drawing, from the "literature" of writers, in order to give birth to a new language: a new departure for a language in which writing, music, color, and drawing would not draw apart again from each other. Yes, that too happened suddenly, "by a stroke," the "lightning" was there, and the "thunder" to strike the date of this birth, the ineffaceable event in its singularity sealed off. A blow "of the tongue," to be sure, but helped "by my black pencil." Helped [*appuyé*]: aided, sustained, prolonged, but also under the pressure and the incisive impulse of the graphite.

Ten years ago language left,
and in its place there came
this atmospheric thunder,
> *this lightning,*

. . .

How?
By a stroke

. . .

> *of the tongue*
by stubbing with my black pencil
> *and that's all.*

. . .

I say then that language distanced is a lightning that I brought on now in
> *the human fact of breathing, sanctioned by my pencil strokes upon*
> *the paper.*
And since a certain day in October 1939 I have never again written with-
> *out drawing.*
Now what I am drawing . . .

Shall we say that on this date, "a certain day in October 1939," the subjectile will no longer be accountable for that treason of which Artaud had accused it on September 23, 1932? Shall we say that from now on the subjectile will no longer betray Artaud's signature, and that across the adroit awkwardness claimed from now on, across the craftiness of the address, Artaud's pictographic work only attains its idiom after this departure of language and this "stroke . . . of the tongue?"

I believe the hypothesis reasonable, but its verification can only be approximate and not absolute. For essential reasons, we can only calculate: on one hand a hypothesis is also a subjectile, and the subjectile a working hypothesis, as one might say a work table; on the other hand,

the rupture dated like that was prepared for and announced too long in advance, so that it has too little of the sense of an arrival at a destination, remains too foreign to sense, too *unsensed,* to accommodate itself to the rational order of such a story.

Let's retain the hypothesis nevertheless. Let's posit that the language thus distanced, finding itself so truly "distanced," let's suppose that there has taken place a departure, a split and a separation, or a certain birth, let's suppose that in the place of the "written letter," the "letter" has finally come, literally, not simply come back, but that it has become literally literal, what it was destined to be, when "I have never again written without drawing."

In 1946, a year before the reminder of this "certain day in October 1939," Artaud names the subjectile a second time. He interprets and assumes once again the maladroit motif:

This drawing is a grave attempt to give life and existence to what until today had never been accepted in art, the botching of the subjectile, the piteous awkwardness of forms crumbling around an idea after having for so many eternities labored to join it. The page is soiled and spoiled, the paper crumpled, the people drawn with the consciousness of a child.[70]

That is the subjectile having fits. It must have suffered, this subjectile which formerly used to betray, it must have suffered everything that as a support it had to withstand, and to withstand passively under all the blows: it's that passion and the torture of the "paper crumpled," of the "page . . . soiled and spoiled." This time, or at least in appearance, it no longer betrays, it is no longer the master, not even a master of truth. But it remains a place of birth. And what is then born in this spot, to this empty and indeterminate place, the in-born to which it is a question of "giving life and existence" by drawing like a "child," is what marks pre-

cisely the death of the subjectile as such, the end of its authority. Violently mishandled, the *parergon* will be from now on incorporated in the work, it will make part of it. Its exteriority, its transcendent neutrality, its mute authority will no longer be intact.

Once again, the exhibition of awkwardness, that of the "forms" and that which mistreats the support upon which we see them crumbling, in no way signifies the technical weakness of some puerile draftsman. It lays bare the original disaster, again the sexual awkwardness of god, after which there is technique, art, the fine arts, and the "drawing principle." The awkwardness is not in the drawing or design, it is designed—by design.

The subjectile took up the space. Now we have, through the "botching of the subjectile," but in itself, in its place, to make room for what had never been "accepted." To bring it about that failure, the fall, the coming due and the decadence, the dejection of the subjectile will finally be accepted. Acceptance, *reception* on the subject of a subject, and of something that figures precisely the *receptacle,* of something that is almost nothing and that must be replaced in its place by place—for the subjectile is nothing other than the empty placing of the place, a figure of the *khora,* if not the *khora* itself. Now this reception supposes a reversal of values, meaning upside down and out of sense at the same time. But the out of sense will take on a sense, more sense: insensibly. The subjectile had always been subjected, subordinated, neutralized in its almost effaced place as a support. But from this place, and surreptitiously, undertaking this transcendent neutrality, it commanded. From then on incorporated, treated, and summoned as such, *it will be a part.* It will be put to work. And this is what has to be received. Twice the word "accepted": "to give life and existence to what until today had never been *accepted* in art" and, in the paragraph following, "I wanted all this anguish and exhaustion of the consciousness of the seeker in the center and

around his idea *to take on some meaning for once*, for them to be *accepted* and made part of the work accomplished."[71]

The trace of the failure made work, the passionate and pulsionate trace of the breath lost but also of the expiration. The "breathlessness" inscribes itself in the very work, incorporated in the support and incorporating in its turn the *parergon* that it rehabilitates and thus legitimates.

Following the injunction, we will no longer be able to separate the drawing from the writing: the writing in it and writing outside of it, apparently dealing with it (by the so-called "commentary" of the "drawing to be looked at sideways" which is explained by the "botching of the subjectile"). We would like to *take account*, in sum, of two works and two subjectiles, two papers, one coming after the other and dealing with it, the one *on* which there would be held a discourse *about* the other, a "commentary" dealing with the other. But this is not to be. The texts are different but inseparable, neither of the two is subjected or subordinated to the other, as its second. There are two subjectiles for one work, and in truth, two unique examples of the same event, absolutely different but indissociable. Is this even possible? But if it were not impossible, what would be the interest?

The "drawing to be looked at sideways" contains some words, it inserts them, and even the caption plays a role, becoming a title—formal and active, I mean active by its form and its place, in the arc of a circle *above* the painting. Just as the words "at the bottom" and "underneath" are found at the bottom and underneath, on the right, just above—precisely—the word "right." A gesture at once crafty and adroit. All these places are marked, above and below, on the subjectile which is always found underneath.

But although by itself each text is incomplete because it refers through the other and supposes it, the "drawing to be looked at sideways"—itself, if we can put it like that—exhibits a sort of "piteous awk-

wardness of forms" which, even being quasi-deliberate, contrasts no less with the extraordinary perfection of the other text, a simulacrum of descriptive metatext which nevertheless belongs to a whole that is not closed: what is called the "commentary" of the drawing by its author. A mastery here, to be sure a transgressive mastery and one driven mad, but sovereign, without the least hint of weakness in the verbal control. The "reading" of the picture unfolds like a poem, it sweeps everything along in its breath, even the breathlessness of which the other subjectile bears the scars. The intonations, the alliterations, the violence of the syntax strike, as it were, so many successful blows. Address itself, beyond address and fine arts. Only another poem can measure up to it. We have to call on another poetic pictogram to acquit ourselves of the reading of this one, thus producing it, in a certain way. Like the drawing, the poem hurls out its words: a powerful projection of literal atoms, and forcefully organized, for example around the letter R and the syllable TR, in other words, around the leTTRe, like the *l'ETRE* of *l'auTRe* [the being of the other] in the truth of its *ETRETé* [beingness], as a protest signed, consigned, countersigned askew, in the harsh consonants of the signatary, against "la fausse êtreté" [false beingness]. We have to look at the *tr* sideways [*de traviole*]. A single stroke links together, in the same breath, the *tr*unks (twice: two trunks") to the "*tr*uncated parts of a mutilated body" and to the "excavation mutila*tr*ice des choses" [the mutilating excavation of things], to the *âtre* [hearth] (twice the âtre, once "above this arcane man," once under l'être, "*pendant que l'être sur l'âtre sombre de sa synovie se fera*" [while being is composed upon the somber hearth of its synovia]), and to *l'être*, being like a word drawn *à la lettre* [literally], drawn in its *lettres* [letters], which, outside of sense, offer themselves to be visible and to be understood as such, "atoms of a being that does not exist." This literal bombardment of projectile letters is not only evoked by the representation of a cannon whose sexual outline haunts so many other drawings. It

is named, like a bombardment of the being, in the text itself, named and exhibited, designed and practiced. For example, and I will not take any more account of all the *t*'s and the *r*'s,[72] their agglutination or their distant attraction, the alliterations or the anagrams that writing forges behind the scenes, as "in the secret crucible-tomb of man":

. . . in this work there is an idea. That of two columns and two trunks, the two lateral sides of true being of which each is a unique mounting, like the truncated parts of a mutilated body when in the secret crucible-tomb of man who was preparing it, the two trunks of the exploded breath condense like breasts, the suspended breasts of a hearth which flames above this arcane man who torments the matter in himself to have beings come forth instead of every idea. —And the lateral trunks of the soul are the members of this idea. —The idea will go. Where will it go. It will go but it won't go at all. Consciousness will vomit it out. Let what rolls in the kneecap roll while true being will form itself on the somber hearth of its synovia. And where are the synovia? In these exploded globules of the body, which every soul holds suspended in its emptiness to bombard with them the atoms of a being that does not exist.[73]

The bombardment of the atoms of being, of the letters of the word of being that does not exist, the bombardment of these atoms of beings themselves bombarded by the projectiles is pursued in the second wave of the text, relayed by *la terre* [the earth], *l'être dans l'absolu* [being in the absolute], *la matière* [matter], *des siècles d'être* [centuries of being], *l'homme enterré* [man interred], *les prêtres* [the priests], *la fausse êtreté* [false be-ingness], *l'êtreté*, and so on. This literal thunder, itself named in the text, is interpreted according to the materialist and atomistic style because the "emptiness" of the atomists is certainly named therein, and because another word in TR, *matière* [matter], the subjectile of all words, represents the empty place of the torment and the mutilation. Arcane man holds his

hand on his sex. If he "torments the matter in himself to have beings come forth," what he is hiding and showing thus, the place of torment, in other words, of work, is under the hand, a single hand, the phallic *and* uterine matter, the projectile *and* the orifice of birth-giving: the matricidal subjectile, the double organ of a phallic progenitor, father and mother at the same time. "For I am the father-mother, / neither father nor mother, / neither man nor woman . . .".[74]

This cohesion of the poem in R, TR, BR, RA: *ira, fera, vomira,* and so on doesn't have to do only with form: it corresponds to a powerful setting of thought, to a sort of fantasmatic mythos, pulsating beyond both knowledge and philosophy. Let's not try to translate it in philosophemes or in theorems. There is the secret, the crypt of this "secret crucible-tomb of man," this "arcane" man. He torments or draws, with his hand on his lower parts, the matter of offspring. At the level of his hand, a cannon and then another, like an earphone at his ear. The "idea," named five times. "Around" it everything is organized, rises, crumbles. The two columns rise or set themselves up, to be sure; they move forward, they throw themselves (and *jacere,* to throw, we remember, means also to throw down in the sense of founding, instituting, hurling, raising), but inversely, "around" the same idea of these two columns *raised up,* it is awkwardness [*maladresse*], the other dimension of *to throw* (to be stretched out, lying down, reclining, struck down, fallen, crumpled on the ground): "the botching of the subjectile, the piteous awkwardness of forms crumbling around an idea." A composition of forces. There is a "work," the word appears twice and the work only holds, only resists decomposition by the tension balanced for one moment between the adroit and the maladroit, the rise and the fall. *Jacio / jaceo:* a double signature at the privileged moment of the coming due. A double conjecture. A signature is always conjectural. That is the idea, from the adroit to the awkwardness, between adroit and maladroit, the center of the work, at the place of the

hearth. This center—for it is the question of the center that "torments" man when "he torments the matter in himself to have beings come forth"—resembles a radiant sun. Not the sun of true being but that of the hearth "which flames above this arcane man who torments the matter in himself . . .".

Being is not, it is not present, it remains to be born, like the "beings" who will come forth from the matricidal phallus of the arcane man. A promise of the being to be born, a future of the in-born as the future of the idea, precisely that of the work. The gloss, if it can be put like that, and the stroke of the tongue, the voicing of the *future*, all that hears itself resounding in the text in one final RA, the grammar of the future, itself inscribed in the drawing, upon the body of the subjectile, upon the breasts, within the columns: "And the lateral trunks of the soul are the members of this idea. The idea will go. Where will it go. It will go but it won't go at all. Consciousness will vomit it out. Let what rolls in the kneecap roll while true being will form itself on the somber hearth of its synovia. And where are the synovia? In these exploded globules of the body, which every soul holds suspended in its emptiness to bombard with them the atoms of a being that does not exist."

Everything happens as if the generating force of the drawing, what literally informs the forms within it, were to forge itself first of all in the tongue, in the trachea rather, in this place where the glossematic differences do not yet signify, all driven mad, outside of sense as they are and ready to supercharge themselves with sense. The lines and the places, the distribution of strokes and of graphic representations would follow a pattern, for example that of the difference between *être* and *âtre* [being and hearth]. Just so, the TR or the BR would literally give orders to the eye and to the hand: draw trunks, truncated parts, traces, a hearth, breasts, a somber hearth, a man interred, and so on. Naturally, it doesn't happen like this, and everything is engendered according to a body in which these

orders are not yet articulated. Neither chronology nor logic, nor hierarchy between the order of the tongue and that of the hand, between the ear and the eye. This order does not *articulate* itself except in the normed and formed epoch of the subjectile: the *organized* body, the five senses, the matter of the support exteriorized in a *parergon* and surreptitiously making the law from its supposed neutrality, and so on. Before this articulation, no difference between the sounding of the TR, for instance, and the visible phenomenon of the trace, the trunk, and so on. No visible or audible difference, in any case, not articulated. No hierarchy of principle, but another force of propulsive training. And the moment of *articulation* is marked in this drawing that could be analyzed as a reverse generation, the genealogy of the being of the future body sideways, seen *askew*, the degenerescence of the subjectile body, the decomposition of the labile, docile, tractable being. The *synovia* make a good articulation possible. The word comes from Paracelsus, gathering up, holding in vitality and in suspense so many germs and semes in its ovula that a synthesis can only sin by omission, also an analysis. *Synovia* designates the liquid that oils the articulations, for example, letting "what rolls in the kneecap roll while true being will form itself on the somber hearth of its synovia. And where are the synovia? In these exploded globules of the body, which every soul holds suspended in its emptiness to bombard with them the atoms of a being that does not exist."

We might be tempted to say that it *doesn't yet* exist, that it is to be born, shown at work, *in travail* in the drawing, an eschatological, messianic, salvatory ("to save the soul . . . "), apocalyptic promise. Let us think about all of Artaud's texts about the last judgment but also "Pour en finir avec le jugement de dieu" (To Have Done with the Judgment of God). And in fact, right here, the dimension of the future is several times marked; in the *ra* of the *ira* [will go][75] (rather than in the *come* of the Apocalpyse), of *vomira* [will vomit], of the *se fera* [will form itself], said of

ideas or being, in what *se prépare* [is preparing] for being while humans have been "waiting for centuries upon centuries to be fabricated by god . . .".

And yet. What remains to come and announces itself here in labor, in travail, will no longer have the name of being: it will be something else, whose future will no longer be the reconstituted, restored, redressed, resuscitated presence of the "beingness" of being [*l'êtreté de l'être*]. Neither theology nor ontology for this *êtreté*, for this *être T* of *l'être*. (Twice T in the proper noun.) The future will be what it must be, *absolute*, thus beyond any present-being-to-come, thus beyond being. To be what it must be, the future, *it must not be*, but rather, go (*ira*), be about to come. *Ne pas être, naître.* [Not to be, to be born.] That supposes another *labor*, another apocalypse, another martyrdom, another *suffering*. As we will see later, the subjectile must be made to suffer and to labor differently. The classic subjectile, that of the fine arts, of theology, of ontology, apparently supports without suffering, without gestation, without incubation, without this travail of labor from which the other of true being will be born. It lies recumbent [*gît*], but without being in confinement [*gésiner*]. We know that the old word of lying-in [*gésine*], coming from "to lie helpless" [*gésir*], signifies the birthing of a woman.

The travail and the suffering of the other, the other travail and the other suffering then, such is the point of the pictogram entitled *Dessin à regarder de traviole*, the point also of the text that, seeming to comment on it, is in fact as separable inseparable from it as its matrix, the margin of its generating phonogram:

Now during this travail, the man in chains issued from the earth suffers with war at his right side [from the right side of the man, to the picture's left, we see the cannon: the right, the law, the address, the rectitude, the rectum, the orthopedic norm, but also the gaucheness, the phallic figure, the project-ejaculation, and so

*on]. Blue from horror with an iron yoke on his head, the man of this humanity. —
And whence comes the evil that the being in the absolute prepares for himself while
the man with the severed arms, a matter of mutilation, has been waiting for centu-
ries upon centuries to be fabricated by god. The point is it's not god who makes man
but a man himself interred, and the man issued from this man finishes himself
afterward. — While the priests of god good at the very most for caressing their
beard are turning their buttocks to that activity, to that mutilating excavation
[mutilatrice (mutilating and scarring) and cicatrice both have l'être as a hearth
or matrice (matrix), as we would say here, for the pictogram in its entirety, includ-
ing the subjectile that supports it and even finds itself represented right in itself,
for example, in the place of the mutilating excavation, in the genital utero-phallic
orifice (upon which the man places his hand)] of things that works in the body
stretched out to save the soul from a false beingness.*

What does this beingness consist of?

*Of swallowing up in the eucharist all the blood and the synovia of the eternal
tortures of man, without oneself having suffered anything and coming afterward
to teach the martyred man what he is suffering, when oneself is no longer
suffering.*

And how do we know this?

In caressing one's beard, while man stinks in his own blood.[76]

Who is the subjectile?

A support, an instrument or a succubus, it puts up with everything
that comes to lie down or throw itself *upon* it, much as one lies down or
as one throws something on the paper. It puts up with it, but without
suffering. It suffers this or that, transitively, without suffering—intransi-
tively. It occupies the place that Artaud has just defined in *execrating* it, in
rejecting it: "without oneself having suffered anything and coming after-
ward *to teach* the martyred man what he is suffering, when oneself is not
suffering."

The word *execrating*, the malediction or the conjuration of the sacred evil, cannot be written without associating what it says with *expression*, *expulsion*, and excrement: a rejection outside and separation. *L'Exécration du Père-Mère* (The Execration of the Father-Mother), this drawing from April 1946, would also put us on the track.

The subjectile (who is it?) suffers everything without suffering. Thus without complaining. It is in inaction, but remains impassive. It accepts and receives everything, like a universal receptacle. As it figures also the place, the placing of all the figures, we think of the *khora* of the *Timaeus*. But let's let this memory wait.

A subjectile is patient, it waits for everything, is attentive to everything but remains impassive. It is a place of incubation. It takes upon itself all the forms, supposes or presupposes and so subtracts itself from all oppositions, for example the one of the man and the woman, even of the father and the mother. It takes the forms that are determined *upon itself*, it takes them upon itself without assuming them, that is why it is exasperating. It takes upon itself without assuming it the utero-phallic form of the father-mother in the *Dessin à regarder de traviole. On one side,* the subjectile is a male, *he* is the subject: *he* makes the law from his supposed transcendent neutrality. He is the father, he gives lessons, comes *to teach,* even as he knows how to be silent, for he speaks the law in keeping quiet. He is like those two columns of the law, like those two cannons that represent him: tattoos on his body. But *on the other hand,* and also inseparably, this same *subject-he* [*sujet-il*] makes all the signs traditionally interpreted as attributes of femininity, even of maternity. First, he is a substance, even the matter of a *hypokeimenon,* and not an attribute, precisely. A matter or a matrix stretching out beneath, and whose beneathness receives the advances and the moves forward, the projectiles and the ejaculations; it easily becomes the *object* of ambiguous aggressions, it exposes itself passively, one might say, to the marks and the seizures of instruments or convex organs, the hand, the penis, the teeth, the

pencil, the pen, the brush, the fire of the match or of the cigarette, the cannons, the lightning, or the bomb. Then the subjectile, this woman, is also a mother: place of travail and of birthing, lying down and lying in at the same time. In vain does the word *subjectile* have an *il* inscribed in it, its phonic form retains resonances conventionally associated with the feminine, precisely in its *il*, in the sound *ile:* fragile, gracile, docile, the slight weakness of what is more gracious than powerful, the aerial, the ethereal, the subtle or the volatile, even the futile. The subjectile *breathes and flies.* (How are they going to translate that?)

The subjectile-flies. The innate child that this father-mother secretes away in its crucible in itself. The subjectile would not only be the androgynous father-mother, incubus succubus that it represents even in itself (the two breasts, for instance, the "it will go" and the "but it will not go yet" *inside* these two phallic columns of the law), it is also the child, the progeny, the "beings" projected, procreated, and thrown which must "come forth" from there. The subjectile-he and the subjectile-she steal them in identifying itself also with them. In the genealogy of this textile, we can count *tous les fils* [all the threads or sons] *et filles* [and daughters] of Artaud. The subject as a subjectile, it's *me*, the me that adds itself or subtracts itself, to support them, to or from all the figures in the utero-phallic scene, it's the *and me* of *Ci-gît* (Here Lies). For really, what is the subjectile if not the meadow of a here-lies? The beginning of *Ci-gît:*

> I, Antonin Artaud, am my son, my father, my mother,
> and myself;
> leveler of the idiotic periplus on which procreation is impaled,
> the periplus of papa-mama
> and child,
> soot of grandma's ass,
> much more than of father-mother's.[77]

But then what?

What is the subjectile exactly? No matter what, everything and no matter what? The father, the mother, the son, and myself? just for good measure, because we could say the subjectile, it's also my daughter, matter and the holy Spirit, matter and the form of forms, the support and the surface, the representation and the unrepresentable, a figure of the unfigurable, the impact of the projectile, its target and its destination, the object, the subject, the project, the subjacent of all these spurts, the bed of the succubus and the incubus, etc., the *et cetera* even as the place of universal incubation, the absolute preoccupation,[78] what bears everything in gestation, manages everything and gives birth to everything, being capable of everything.

In short, everything and no matter what, so that there is no more sense, rather some maddening-of-sense to asking: "who is it?" Can one even ask, or wonder, "what is it?" "It's what?" No, it's nothing, nothing at all, no determined being, from the moment that it can take on the determined look of anything at all. Transcendence of the Other—and of the One. Beyond being, *epekeina tes ousias:* "I am one and not numerous," says Artaud, and also the subjectile.

That's how he exasperates, and she too, that's what the thing we call subjectile begins by calling gestures, and the most contradictory gestations and gesticulations. We have to determine *and* drop.

Everything *and the rest,* this is what it is without being it. And the rest remains inconceivable, even if it makes a place, its place for any possible conception. It has no propriety, it is proper, thus improper to take them on, to take, to understand them all [*prendre, comprendre*]. We have to start with what takes place with the impropriety of a subjectile.

A place, separation and receptacle, difference, interval, interstice, spacing, as the *khora:* neither sensitive nor intelligible, neither the mimetic copy of the paradigm of the *eidos,* nor the paradigm or the model

themselves, rather a "third *genos*," difficult to conceive except as a hybrid "bastard reasoning," as "in a dream," Plato says in the *Timaeus*, in a dream but beyond every sensation. This *anesthesia* doesn't mean that the *khora* is intelligible. It holds itself, like the subjectile, underneath, and it is thus that it merits its name of receptacle: *hypodokhe*. And we *compare* this receptacle to a nurse: "What propriety (*dynamin*) must we suppose (*hypolepteon*) that she has naturally (*kata physin*)? Before anything, someone of this gender: of every birth (*pases geneseos*) she is the receptacle and like (*oion*) the nurse" (*Timaeus* 49a). *Like* the nurse: only a comparison, a figure.

With Artaud, mustn't we come back from Latin to Greek, especially when it is a question of birth and of nursing, at the hearth of language, maternal or matricidal?

This kind of nurse who "receives all the bodies," we must "give her always the same name," for she never loses her proprieties. Receiving all things, this receptacle never takes any "form" like those that "enter" into it: it is, "by nature, like a bearer of impressions (*ekmageion*) for all things." The support is "set in motion and cut out into a figure" by the things that "penetrate" it. And yet, it must remain heterogeneous to everything it receives, "absolutely exempt" itself "from all the figures" that come to inscribe themselves in it; impassive, transcendent and subjacent, unfigurable receptacle of all the figures, keeping its unalterable property of not having any and of being sufficiently undetermined, sufficiently amorphous to take upon itself all the forms. Upon him, upon her: the comparison of the nurse is followed by a comparison to the mother: "For the moment let it suffice to fix in one's mind these three types of beings: what is born, that in which it is born, and that in the likeness of which what is born develops. And it is fitting to compare the receptacle to a mother (*metri*), the model to a father (*patri*), and the intermediate nature to a child (*ekgono*)" (50c,d). That is only a comparison, a figure of rhetoric,

thus, a particular form that can also receive the *khora*. In itself, so to speak, it is no more to be confused with the mother than with the father or the child. It remains indifferent to the figuration and to the substitution of places that all take place in it, the place and the spacing itself. We have only to read all the *Cahiers de Rodez*, without which the drawings of this epoch would remain more unintelligible than ever: we will better understand the eagerness around the subjectile, against this indifferent, impassive, amorphous, undetermined *khora*, all-powerful in that and yet nothing, one and the other at the same time: that is why we have to force her, give her sense while she is herself, outside of sense, unsensed; the *khora* must be determined, given her place, although she is the place that she gives, given her form and the in-born cause to be born there. And for that, we will soon verify it, we must attack her *and* protect her, drive her mad, making her lose her sense, that is to say, her identity and her propriety, but as this sense consists in not having any, the driving mad comes down to trying to give her finally a figure or sense, and from then on to confining her to it: *a double constraint and a double conjecture.*

There is no question of getting out of it here. We can only subscribe—and sign.

A year after the *Dessin à regarder de traviole* and the "botching of the subjectile," Artaud again names the subjectile, for the third and, to my knowledge, the last time. This is in February 1947. The father-mother receives its name but a *relation* isn't clear, no more a relation between the two ("*or*") than the relation to the figures or the relation to the subjectile. What does "through father *or* through mother" mean? "without the subjectile ever complaining through father or through mother"? Do the father or the mother represent the subjectile as these "figures" that it supports, indeed like its *porte-parole*, or are they *the* subjectile itself?

The figures on the inert page said nothing under my hand. They offered themselves to me like millstones which would not inspire the drawing, and which I could

probe, cut, scrape, file, sew, unsew, shred, slash, and stitch without the subjectile ever complaining through father or through mother.

The subjectile figures the Other, or rather the Other having become the adverse party, the opposed *supposed,* the place as a carrier of all the instruments, succubi and incubi,[79] representatives of all the representatives of the rape to countercommand. This is confirmed at once in what, by artifice, we would distinguish as the pictographic practice of Artaud *and* in his discourse: the three times when he names the subjectilian Thing. That the Thing—which is above all not a thing for hypostasis—*should betray,* that it should be, in its very "botching," what he must "give life and existence" to, that is what was clearly shown. But that means at the same time that before being a place of birth, lying-in or genesis, the theater of abortions or of new bodies to come, the Thing can solidify the powers of death, the subject of god, the instruments of crime, the objects and toys of a malpractice. Attacked insofar as it offers the hospitality of its bed to the instruments and the succubi, it must be cared for, prepared, repaired, prepared insofar as it bears or supports the in-born still to be born. Life and death at once, a family without a family. Subjected to the force of evil, announcing the devil, damning and damned, thus obscene, uncontrolled and unbearable, it must be in its turn reduced by the other force, subjected to a counterforce. And this awkward adroit forcing is destined to have the in-born born, and if it is necessary, with a forceps.

"... without the subjectile ever complaining through father or through mother." How should we understand these last words? How to understand this silence or this mutism, because these words describe a subjectile closed up in that very thing, in the very fact that it is not saying anything, in the obstinacy of not showing? It reveals nothing of what it is feeling, suffering, bearing, it does not answer *to* what affects it, nor *about* what happens to it. But perhaps it feels nothing, perhaps it has nothing to bear or to suffer. It does not complain: that can mean that it

bears things in silence. Passion, martyrdom, and torture of the subjectile. But that can mean that at bottom, at the bottom without bottom of things that it is, *it has nothing to complain about*. It is not so badly treated. Perhaps it is taking its pleasure in silence.

On the whole, this subjectile subjects itself to the surgery it is subjected to: the subjectile is this, that, that again, *and me*. And let's not hesitate to say it: the subjectile is all that and Antonin Artaud. And me. And as all that holds together "under my hand," the surgery resembles a manual demiurge *at once* aggressive *and* repairing, murderous *and* loving. The Thing is reconstituted, the cicatrization comes to it from the very gesture that wounds it.

But let's be careful, it isn't about the subjectile, not about itself, not immediately that we were supposed to be speaking here. The complaint would arise, if there were to be one, "through father or through mother." Intercessors, mediators, representatives, actors, fetishes? And moreover the subjectile is always spoken of by interposed "figures." What is keeping silent? What didn't say anything? The figures, *"on the inert page"* and *"under* my hand." I am stressing *sur* and *sous*. As for the subjectile, it stretches out *under* the figures which are thrown *upon* it to be submitted there to the furious surgery ("probe, cut, scrape, file, sew, unsew, shred, slash, and stitch . . ."), furious as we saw with madness but also with amorous passion. The figures are not saying anything, nor the inert page, and the only complainant is Artaud. Mute and apparently inanimate, the figures seem however to *summon* all the blows, "they were offering themselves to me," but they call then without inspiring the drawing, without having the breath or the spirit come. Inert millstones, lifeless, soft, detumescent, if we think about what associates the millstone to the unformed and inorganic heap, to the pile of vegetal substance heaped together (wood, straw, the millstone of manure, etc.). But again millstones, just as mute and inert, whose abrasive matter, a cylinder of stone or metal, even a molar,

becomes a body suited for rubbing, sharpening, scraping, wearing out. And the paper of the "inert page" would then resemble sandpaper against which a pointed pencil would have to sharpen itself, but also to whittle itself down. Let's leave this millstone word (a word is a millstone) with its formal or semantic associations. Let's just be aware that it frequently appears under the pencil of Artaud—who loves it then and cultivates a word, for example "subjectile," in order to speak rather ill of the thing.

The figures, then, and not the subjectile itself, if at least something like that existed. The subjectile is never literally what it is. We always speak of it by figures. You perhaps are thinking that, forcing[80] the thing a little, I have been telling you the story of the subjectile for a long time, and its calvary in short, with its three stations. No, the subjectile has no history. It is what has no history, even if its name has one, for it never exists under that name. It is in any case what is *made for, destined* to have no history. The history, others would say the myth, only recites its tropes, and the interminable permutation of its figures.

These are "the figures . . ." that "I could . . .".

That I could have what?

Let's be satisfied, finally, with this remark. What I could, myself, always has the double value, double and nondialectic, of an operation. A surgical operation, we have seen, a work of the hand and of *man's hand.* An arithmetical multiple operation (to add and multiply in subtracting, to make larger by destroying). An operation that *works,* when everything is taken into account, across the ambivalence of the gesture, leaving the martyred witness of an *opus:* there remains the trace of an operation that could have gotten carried away itself, and been driven mad. What is outside of sense remains.

Each gesture, and first of all each verb, has this double value.

To probe: (1) The probing instrument works by penetration, it plumbs the depths, perforating the surface and passing through to the

other side. "I could probe . . ." means then: I could make the most inti-
mate of moves, by transgressing a limit, under the skin, once the epider-
mis was pierced. The element through which an underwater probe delves
is liquid like the sea—the "mother waters"—offering little resistance to
the probing tool. It can sink down like a *mine*, ready to incise a stroke
with a pencil lead [*mine*] or to explode. But I could also probe a terrain
as if to reach some ore, and this leads to the other sense of the probe,
inclined less to the aggressive or transgressive intrusion than to the desire
for truth. (2) I could probe to try to find out, to discover the truth under
the subjectile, behind the veil or the screen. I could with the point of a
lead instrument try to learn, to decipher the sign or the symptom of a
truth. The sounding probe prepares the diagnosis like this. To probe the
figures at the moment when "they offered themselves," by refusing or
exposing the inertia of a sick body, is to prepare oneself to treat them for
their good, starting with their own truth.

To cut: (1) "I could . . . cut" the figures by wounding them, I was
certainly able to notch and gash them, slice and incise them, cut them
up, hack them to pieces. With scalpel, scissors, shears, knives, needle tips,
or feathers: cut, notch, diminution, castration. But to cut (2) is also to
regenerate, to strengthen by loping off everything restraining the growth,
to prune, thin, cut back, rejuvenate, render strength to a tree or a member,
in short, to save, physically or symbolically, to come to the aide of a sub-
ject or an object. To enable it, like *physis*, to grow and spread out in its
truth, revealing itself as it grows.

To scrape: (1) "I could . . . scrape " because I could irritate the surface,
attack by rubbing with the aid of an instrument at the very tip of the
hand, and this could be the nail. In scraping I risk wounding, I cause the
loss of the substance to the body about which I am speaking like this. I
hold it against the skin. But (2) in scraping, I purify, I appease, I efface
what is written to write again. Like the copyists of the Middle Ages, I

flatten the parchment, using an instrument that at once polishes, prepares, and scrapes the surface upon which new inscriptions, which I am "scraping" also, could tell the truth, unless the laying bare of the support or of the subjectile by the scraping itself does not yet constitute the *operation of truth*. In brief, by scraping, I can also save the subjectile in its truth, accede to the other surface as it is hidden, asphyxiated, interred under the deposit.

To file: (1) "I could . . . file," *break into* the figure in yet another way. Still by rubbing, to be sure, and scraping, but this time according to the obliqueness of the metal teeth, molars against millstones. But (2) the aggression which thus reduces the surface is destined to polish, make delicate, adjust, inform, beautify, still *save the truth* of the body in straining it, purifying it, removing from it any uncleanness and useless excrescences. The taking away of the unclean has the virtue of laying bare and of catharsis.

To sew: (1) " I could . . . sew," and for that I have to pierce with a needle or a pointed lead, perforate, penetrate, make holes in the skin of the figure, but I can sew, (2) and even suture and scar, in order to close the wound that I open in sewing. I pass the thread through to repair, gather, have the fabrics hold together; I adjust the piece of clothing which, covering the surface of the body, weds it in its natural form, reveals it by covering it. The truth again.

To unsew: (1) "I could . . . unsew," unmake, do the preceding operation in reverse, but it was already the reverse of itself. The link itself, like the link between these two operations that consist precisely in a certain treatment of linking and unlinking, the obligation of this ligature is a *double bind*, a double conjuncture. For, (2) to unsew is also to undress, again to lay bare the body under the surface or the surface of the skin under the clothing, or the flesh under the skin. Under the act of war (surreptitiously recalled by the act of *unsewing*), to unsew can again serve or

save the truth, the truth of the body proper. For "the beings have never had any body of their own and that is what I have always *drummed into* them."[81]

To shred: (1) "I can . . . shred," during the same test of force and desire, that is, cut into pieces, into tatters or shreds, slash, hack, wound, mutilate the body with a cutting instrument. It's sometimes the maladroit gesture of a surgeon. *Shredded* linen also names the old cloth (textile is always, along with paper, the best paradigm of the subjectile) from which threads are taken to make bandages, generally in wars. The act of war would be perhaps purely aggressive and devoid of any repairing counterpart without this virtual allusion to the act of bandaging. But the verb *to shred* is caught here, one might say, sewn, into the braid of the last three (to shred, to slash, *and* to stitch). The grammar of *and* sews together the two first verbs [*écharper, déchiqueter*] which say in *ch* the tearing apart of the flesh (shred, slash) and the third, *stitch,* which comes immediately to put in the suture points in order to prepare the scar tissue.

To stitch shares in fact its ambivalence with *to sew* (to pierce through but also to have the tissues hold together, whether skin, fabric, or flesh) but adds its own. Certain dictionaries only give this verb a past participle, *stitched,* which corresponds in fact to the most frequent usage, if not to the only grammatical possibility effectively used. Having recourse to the infinitive, a possibility mentioned in the Littré dictionary, Artaud invents or discovers a rare usage in order to stress an activity, a labor, an eagerness. To occupy oneself with stitching is never to cease *covering with scars.* For such is the sense of this verb that only relates sewing and stitching to the flesh. To have the body stitched is to be able to show it covered with traces, the scars of blows and wounds. But "to cover with scars" may mean at the same time to multiply the blows and wounds *and* the gestures of reparation, sutures, and bandages which belong to the moment of scarring. Surgery does both, successively or simultaneously. It operates here,

let's not forget it, upon the figures that are *cut out* in relief against the ground of the subjectile, in the subjectile itself but without getting confused with it. It will always remain withdrawn. It's a ground without ground. It exasperates the eagerness of the surgeon before such an inaccessible background behind his figures, figures that are his but that are not proper to him. In this indeterminate ground, the subjectile neither lets itself be taken, nor figured, nor determined, it does not let itself be *terminated.* It is in-finite but, insofar as it is indeterminate matter, it is a "bad infinite," as Hegel would have said, a negative infinite, an indefinite. A *bad* infinite, Artaud might translate, a shady indefinite, obscene and worked over by the forces of evil that it represents, inhabited by fiends and by the succubi that it *makes banal* under its neutral surface. It never appears itself, only by interposed figures. Surreptitiously, a place where everything appears, itself it disappears under the phenomena, it's the thing in itself or again the transcendental object = X taking the relay of the *khora.* Negative theology. Really no matter what, the no matter what as a bad infinite. We have then to finish with it, to determine it so as to finish. We have to have done with the subjectile. And, for that, to determine it, to *analyze* it in making it come out of itself. Let it finally become something or someone! Let it bear its name, its own name! We have to have done with the judgment of the god of all the negative theologies, and to end it with its own hands. Surgically, pictographically.

But what are they *doing* here, and who *are* these figures of "father or mother"? Why does all this ambivalent manipulation endure "without the subjectile ever complaining through father or through mother"? The response to this question should mobilize the whole corpus of Antonin Artaud, in particular but not only *Artaud le Mômo* and *L'Exécration du Père-Mère* (text and drawing) which date from the same epoch. Very arbitrarily or for reasons of economy (it's a matter of economy, of hearth, of the family home and the law of the *oikos*) we will keep ourselves from

wondering what "father" and "mother" *mean* here.[82] All the more since precisely the figures are saying nothing. Through them the subjectile never complains.

It never complains *about itself*. Which can *mean* [*vouloir dire*] that, subjected to this amorous aggression, to this murderous and reparative surgery, it suffers in silence, it has the strength, this support able to suffer everything without complaining, it's a stoic subjectile. Unless, as an impassive support, indifferent to all the figures that are cut out in relief within it, upon its very ground, it does not suffer in the slightest. And it has nothing to say, nothing to say over again. It wants to say nothing, it means nothing [*veut rien dire*]. An inexhaustible ground of everything that is said or drawn, it has nothing to say itself. Unless again, a third hypothesis, it is taking its pleasure from all this in silence! If it never complains, it means it has nothing to complain about! Manipulation causes it to take its pleasure silently, but ecstatically. The orgasm of the subjectile would attain its acme at the moment of the utero-phallic birth, just as much as in the *unbearable* coitus of the father-mother. It *takes pleasure and gives birth* at the same time, so many reasons for not complaining.

If it takes its pleasure, it's because of having been first seduced. All the aggressive maneuvers (probing, cutting, scraping, filing, and so on) were also, we have just verified it, so many scenes of love and of reconciliation (preparing, repairing, knotting back up, gathering, erecting, causing to bleed, scarring, and so on). The multiplication of advances, the frenzied surgery, the frenetic eagerness of a hand that jubilates, all these always find strength and motion to go further, and this driving mad and out of sense has to do with the structure, let us say rather with the *catastrophe,* of the subjectile: this ground with no ground necessarily provokes the contradictory gesture, leads to the most incompatible relationship, thus the most reversible and reversing, that with itself. It must be at once seduced and traversed, *inflamed* by the caress and *perforated*, in short, *soft-*

ened [*amadoué*]. *Amadou,* this substance whose Provençal name designates the amorous behavior of the *amador,* is used to rub and caress. Rubbing and caressing in order to inflame is done with the help of a colored substance known for its facility to set fire. To soften with *amadou:* to appease, domesticate, flatten, tame the other, seduce or win over the enemy by caressing, but also to burn him, inflame him, set fire to him. This is exactly what Artaud did with the subjectile and sometimes literally when he left those holes of fire in the page.[83] Those were *working.*

The crater makes the work.

It takes pleasure and gives birth, as we were saying. The impossible history of the subjectile will have been taken in the bed of birthing in all its layers [*dans des couches, et des couches des couches*].

(How will they translate these words?)

There are first the stratified layers, the abyssal series of sedimentations. We are supposing the subjectile capable of supporting several layers of paintings, but we have quickly seen that under these superficial layers a groundless ground withdrew behind the surface, becoming a figure in its turn, and so on ad infinitum. There is always more than one layer as soon as a subjectile lies somewhere. And several possible supports. What would Artaud have said, wouldn't he have said, of the "new supports"? and of synthetic voices?

There is then the bed of the subjectile (we also speak of a bed in geological code), the bed that stretches out under the bodies, for sleep or for love, the *cubile* or *cubitum,* the couch, the nuptial bed, the bedroom, nest, niche, an animal *lair.* These beds have privileged hosts or parasites, the incubi and the succubi. Then there are the diapers of the newborn (a subjectile is not only a place and a birthing bed, a *clinic,* a *maternity ward,* it is also a self, *and myself,* the newborn). The diapers then figure this thickness of cloth, fabric, and paper which resemble linens for bandages ; they sometimes let through the excrements that they ought however to

gather or retain, liquid, solid, and semi-liquid. They envelop both the anal and genital parts of a baby for whom the birth of art consists in this impregnation of the subjectile. Whether he is standing or lying down, whether he is walking or sleeping, a subjectile is *under him*, a receptacle of the most aggressive or the most precious deposits.

But first there were the labor pains of giving birth, whether false or real. The "suffering of the prenatal" and giving birth to the "in-born," or the innate. All these birth things are at once a place and an event with a date, a taking-place for which the subjectile would furnish the theater if it didn't remain so invisible. The subjectile *bears* all these birth things, in gestation and then to term.

There is always one more layer to a birth [*une couche de plus*].

The layers of sense in the word *couches* do not let themselves be wholly summed up in the systematic unity of a terrain, they have no final support upon which to rest in an orderly fashion. They form no sense, whence the outside-of-sense, the unsensing. We could say as much of subjectiles. Nothing is *hatching* which is *one* under the subjectile: not even itself. Perhaps a time of incubation, that is all. So there is no sense, and that is what drives us mad, asking: who is the subjectile? And as it remains a stranger to the space of representation which however invests it and institutes it, consolidating it in its technical support, it would not be able to let itself be represented by father, mother, son, daughter, or myself. And yet it wills itself and delegates itself in all these figures. For Artaud, as for me, it has a name, some names, and yet it necessarily retires into the without-name. It remains thus between sense and nonsense, *outside of sense.*

The subjectility of the subjectile summons these two contradictory projects. The story that I have pretended to recount, a certain time of incubation between 1932 and 1947, for the word as much as for the thing, forms only the testing ground for a wall between these two proj-

ects, gestures, or gestations. Between these two adverse tensions. Adversely, they provoke the maddening, driving meaning to madness. But insofar as they balance out, offer a place to the birthing and its traces, *interrupting the fire,* they will have made a work—and kept the subjectile softened. An instantaneous grasp, an institution, disastrous but sublime, of a formidable precipitation of strength. It was necessary to perforate, to throw, to throw oneself against the subjectile with all one's strength, to become a projectile and see oneself on the side of the target, already on the other side, and from the other side of the wall that I also am. I traverse the membrane, and my own skin. I am cast before even being able to cast, into birth.

But I do not traverse, or in doing so, I keep the trace of a traversal, even if the trace is in its turn subjected or promised to the trajectory that it recalls, which in truth it calls. And tries to gather into the signature of its proper name. It tries to introject itself literally there. This *arrest* of the journey makes a work. I understand the *arrest* as the sentence that makes the law, in the name of Artaud, and as the interruption of a thrust, the tonic immobilization of a would-be lancer. Both giving birth to chance.

The sketch of a spurt, what is thrown on the paper all at once, makes what the subjectile is guarding *appear*—superficial and fragile, to be sure, nonsubstantial and inconsistent. But this *phenomenon,* what you see here, the color, the dark light of the stroke, the traces of burning, the enthusiasm of the plumb line, all *constitute* the subjectile which otherwise would be nothing, especially not the support of a signature, the tortured body of a name.

Arrested on the very surface, the projectile mishandles the support with all the phantoms that haunt it, those ghosts of another history of god ("No, there are no ghosts . . ."), the spirits in incubation. But with the same double blow, it gives consistency to what it attacks, incorporating it in the work, making it part of the expression on the path to introjection,

retaining the excrement in the very moment of its expulsion, in exactly the moment of separation, that is of the *secret.* So its secret, at once kept, concealed and yet exhibited, is won but lost in its exhibition. The secret is, as its name indicates, the separation. Partition and parturition. "Ten years ago language left . . .".

As the "organist of an *arrested* tempest," "it seeks the sublime in everything and for everything."

But the signatory adds: "I have not sinned, but I am not responsible. I will not pay but I will make someone pay."

Two of these three negatives seem added on afterward, look . . .

1. I am thinking in particular of "Recherche d'un monde perdu" (The Search for a Lost World), published in this volume, and above all of "Entendre/voir/lire" (Hearing/Seeing/Reading), *Tel Quel*, no. 39 (Fall 1969) and no. 40 (Winter 1970). See also "Notes de travail sur les mots forgés par Antonin Artaud dans ce texte" (Working Notes on the Words Antonin Artaud Made Up in This Text; a commentary on *La Maladresse sexuelle de dieu*), *Peinture/Cahiers théoriques*, no. 1 (2nd trimester 1971); "Lettre à Henry-Claude Cousseau sur les dessins d'Antonin Artaud" (Letter to Henry-Claude Cousseau about the Drawings of Antonin Artaud), *Cahiers de l'Abbaye Sainte-Croix*, no. 37 (1980); "Dessin à regarder de traviole" (Drawing to Be Looked at Sideways), *Café*, no. 3 (Fall 1983); catalogue of the exhibition "Ecritures dans la peinture" (Writings in Painting), Centre national des arts plastiques, Villa Arson, Nice, April–June 1984.

2. V, 274.

3. "Dix ans que le langage est parti . . ." (Ten Years Ago Language Left . . .), 1947, *Luna-Park*, no. 5 (October 1979), p. 8.

4. IV, 39. The translation here is from *Antonin Artaud: Selected Writings*, ed. Susan Sontag, tr. Helen Weaver (New York: Farrar, Straus and Giroux, 1976), p. 234.

5. Artaud does to the French language what he does to the subjectile. He blames it, scolds it, *operates* on it, mistreats it in order to seduce it, etc. From now on, the reader can translate everything concerning the "subjectile" in "French," by "the French language" said to be the mother tongue. But to write *against*, absolutely against one's mother tongue what you can do best, you still have to *leave* it, rest in it, bet on it, *leave it* also for the necessary departure and separation:

We have to vanquish French without leaving it, / For 50 years it has held me in its tongue. / Now I have another tongue under [sic] tree.

To manage that, / starting with the fact that I am French / and in the way that best expresses my present force of will, actual, immediate, human, authoritarian, / and correct / for no matter what is me, my way of doing it is not that of a being. / It will always be me speaking a foreign language with an always recognizable accent.

We will verify it later, you have to repair the sick body, make it as new, really, take it back to the very beginning as an egg, have it born again. And that will be true for the subjectile as much as for French:

As for French, it makes you sick, / it is the sickest, / with a sickness, tiredness, / that makes you believe that you are French, / that is to say, finished, / *a person finished.*

And at the moment of translating, precisely, what he means ("it translates quite exactly what I mean") speaking of what, we will see, inhabits or haunts the subjectile, that is, the fiend, Artaud writes: "It's the basis of the Ramayana not to know what the soul is made of, but to find that it is and always was made of something which was before, and I don't know if in French the word "rémanence" exists, but it translates quite exactly what I mean, that the soul is a fiend [*suppôt*], not a deposit [*dépôt*] but a *suppôt*, which always picks itself up and rises from what formerly wanted to subsist, I would like to say to remain [*ré-maner*], to dwell in order to remain, to emanate in keeping everything else, to be the else which is going to come back up." (Texts quoted by Thévenin, in "Entendre/voir/lire," *Tel Quel*, no. 40, p. 72, and no. 39, pp. 55, 57, 58.)

6. Martin Heidegger, *Unterwegs zur Sprache* (On the Way to Language; Pful-

lingen: Neske, 1959), p. 53. The *trajectory* (as well as the spurt or the -ject of a projectile), in other words the path (*sent, set*) of the *forcènement,* is what we will try to follow here among a number of languages.

7. XIII, 42–43; translation from *Antonin Artaud: Selected Writings,* p. 499.

8. XIII, 43–44; translation from *Antonin Artaud: Selected Writings,* p. 500.

9. "They have dipped me three times in the waters of the Cocytus / and protecting all alone, alone in my obsti-*nate* beingness, / and protecting my mother Amalecytus all alone, / and why now Amalecytus this mother of an obsti*nate* Anteros?" (Quoted by Paule Thévenin, "Entendre/voir/lire," *Tel Quel*, no. 39, p. 32. My emphasis.)

10. II, 204.

11. XIV, 135.

12. XI, 20.

13. XIII, 39; translation from *Antonin Artaud: Selected Writings*, pp. 497–498.

14. Letter of van Gogh, quoted by Artaud, XIII, 40; translation from *Antonin Artaud: Selected Writings,* p. 498.

15. XXI, 265.

16. XXI, 266.

17. IX, 171.

18. XXI, 267.

19. XX, 170.

20. XIII, 28; translation from *Antonin Artaud: Selected Writings*, p. 490.

21. IV, 43. My emphasis.

22. IV, 36–37; translation from *Antonin Artaud: Selected Writings*, p. 232. I have stressed "being projected" and "beneath language."

23. V, 90; translation from *Antonin Artaud: Selected Writings*, pp. 300–301. My emphasis.

24. IV, 37, 39.

25. The theater loses its power when it separates itself from a certain pictography. "The idea of the theater no longer holds the brilliance, the biting quality, this feeling of a unique thing, unheard of, *integral*, that certain written or painted ideas still keep." And still in the Théâtre Alfred Jarry: "The Théâtre Jarry was created as a reaction against the total freedom that exists in music, poetry, or painting, and which it has been strangely cut off from until now" (II, 19, 47–48).

26. IV, 32; translation from *Antonin Artaud: Selected Writings*, p. 228.

27. IV, 34; translation from *Antonin Artaud: Selected Writings*, p. 230.

28. IV, 35; translation from *Antonin Artaud: Selected Writings*, p. 230.

29. IV, 33–34; translation from *Antonin Artaud: Selected Writings*, p. 229. My emphasis.

30. IV, 44–45; translation from *Antonin Artaud: Selected Writings*, p. 239. "Incantation" is the only word stressed by Artaud.

31. IV, 45.

32. XIII, 28; translation from *Antonin Artaud: Selected Writings*, p. 490.

33. XIII, 46; translation from *Antonin Artaud: Selected Writings*, pp. 501–502.

34. XIII, 47; translation from *Antonin Artaud: Selected Writings*, p. 502.

35. XIII, 46; translation from *Antonin Artaud: Selected Writings*, p. 502. My emphasis.

36. XIII, 46–47; translation from *Antonin Artaud: Selected Writings*, p. 502.

37. XIV, 26.

38. XIV, 57. My emphasis.

39. IV, 11–12. My emphasis.

40. XVIII, 75. My emphasis.

41. XIV, 146–147. My emphasis.

42. XIV, 147.

43. Ibid.

44. XIII, 48; translation from *Antonin Artaud: Selected Writings*, p. 503.

45. XIII, 48–49; translation from *Antonin Artaud: Selected Writings*, p. 504.

46. XIII, 50–51; translation from *Antonin Artaud: Selected Writings*, pp. 504–505.

47. XVIII, 75.

48. IX, 22–23.

49. XIV, 23.

50. VIII, 257.

51. VIII, 256, 260. My emphasis.

52. VIII, 253.

53. II, 219–220.

54. II, 264.

55. II, 223.

56. II, 220.

57. I, 146–150.

58. Among other motifs, we should follow in this text, exemplary in so many ways, all the figures of what I shall call, briefly, the scene of the subjectile (the missile or the projectile, the barrier, the page and the division, the wall, and so on, but also the fire of the sky, woman, fiends, the succubus, the witch, etc.) For example:

. . . a volley of arrows shot from below the canvas. As in the branches of my mind, there is this barrier of a body and a sex which is there, like a page torn out, like a bit of flesh uprooted, like the opening of a lightning flash and thunder upon the smooth walls of the firmament. / But elsewhere there is that woman seen from behind who represents quite clearly the conventional silhouette of the witch. . . . Are there so many things in this canvas? There is the force of a fixated dream. . . . A great heap and a great fart. . . . After so many deductions and failures, after all these cadavers taken down, after the warnings of the black clubs, after the banners of the witches, after this cry from a mouth in the bottomless fall, after I have knocked up against walls, after this whirlwind of constellations, this tangling of roots and hair, I am still not so disillusioned that this experience is weaning me.

Let's not forget that "L'Automate personnel" describes a portrait of Artaud by Jean de Bosschère (I, 146ff.)

59. XX, 340.

60. XXI, 266–267.

61. XIV, 77, letter of February 12, 1946, to Henri Thomas.

62. "Le Dernier aspect du Salon" (The Last Glimpse of the Salon) (II, 249). The whole text argues against technique, most of all that of drawing. For instance: "We would seek in vain any mention of color. Suffice it to say that a depressing uniformity in fabrication reduces most of the canvases to the same kind of skill and procedure as the mind of cubism petrifies. We aren't spared even the postcard genre, like some spot of old mud amid the freedom of the other canvases." It is obvious that music, anything with sound, is only heard in color, not in drawing.

63. We have to suppose here, since we cannot quote them in entirety, that the reader has read the "Interjections," in "Suppôts et suppliciations" (XIV). Although each page seems to me to bear out what I have called my working hypothesis, I shall just indicate some of them: 23, 26–33, 39, 46, 60, 65, 69, 128, 129, 135, 147, 204, 205.

64. "Dix ans que le langage est parti . . . ," p. 9.

65. XX, 173.

66. XX, 172.

67. XX, 170–171.

68. XX, 173.

69. "Dix ans que le langage est parti . . .". "Cogne et foutre" (Hit and Fuck) (XIV, 26–30) strikes out against the "written letter," that is, the letter inscribed in the word, subjected to the discursive proposition and its logico-grammatical norms:

The words I use were passed on to me, and I use them, but not in order to be understood. . . . Precisely I don't use them, / in reality I don't do anything except remain silent . . . I don't use any words and I don't even use letters. . . . For thirty years that I have been writing I haven't yet quite found / either my speech or my language, / but the instrument that I haven't ceased to forge. Finding myself an illiterate, this instrument will not take its support on letters or the signs of the alphabet, we're still too near to figured convention in that, and an ocular and auditory one.

The rest of the text analyzes this "figured convention," the one that "linked" "meaning," "thought," and the "formally written tales": it consists still now in "projecting." The "projection" takes place upon the "walls of an immense brain": "A character is an outmoded movement that comes yet once again to project the fucking of a

last phosphorous, / and soon all the words will have been read, / all the letters completely exhausted."

70. XIX, 259. This has to do with the *Dessin à regarder de traviole.*

71. Ibid. My emphasis.

72. On the relationship between these letters (R, T) and the name of Artaud, I refer the reader again to Thévenin ("Entendre/voir/lire," *Tel Quel,* no. 40, especially p. 89).

73. XIX, 259.

74. XIV, 60.

75. For a reading of this *ra,* grammar of the future and clearing of the throat, a semantic ramification and a frenzied death rattle, we would have to bring together all the *ra's* and all the rats of Artaud, starting with those to be heard in his own name: Ar-Tau. As one example in a thousand, in "Pour en finir avec le jugement de dieu (La Recherche de la fécalité)" (To Have Done with the Judgment of God [In Search of Fecality]):

Where you smell shit / you smell being . . . man has been afraid to lose his shit / or rather he has desired *shit / and for it, lost his blood. . . . Then he retreated and fled. / Thereupon the beasts ate him. . . . He developed a taste for that, / and taught himself / to be a beast / and to eat* rat /

delicately. / And where did he get this abject filthiness?

I emphasize these last words. The filthiness lies in his being himself, by a strange perversion, by a forced inversion of the literal meaning, the man who ate the *rat* he became when the beasts ate him. A Last Supper of the name. He took part in the repast during which he was himself consumed like a rat. He "developed a taste for it" in that he swallowed the word or the name *rat,* the sound *ra* in which his name was first inverted, precipitated head first into his mouth, and also in the tongue, the anus, or the testicles. Ingested, incorporated or introjected. Such was the stage of the subjectile, in truth, its *arrest:* "That comes from the fact that man, / one fine day, / *arrested* [Artaud underlines *arrested,* he arrests himself on that point] / the idea of the world. . . . There where you only have to press / the rat / the tongue, / the anus / the testicle. . . . I renounce baptism and the mass." (XIII, 83–86.) Another page, in "Suppôts et suppliciations," more exactly in the "Interjections": "my body / in the future / will be . . . a race of dopes that I revoked . . . and that's where rain, spittle, / come from, / from the first spittle of rat god" (XIV, 17). Inserted in a drawing, the syllable *ra* is also circled with a stroke, then multiplied in *rabut, tarrabut, rarfa, ratura, rarina, arera,* and so on. Such is the *art* of Antonin Artaud, always beyond Art or against the Fine Arts.

76. XIX, 260.

77. XII, 77; translation from *Antonin Artaud: Selected Writings*, p. 540.

78. This absolute preoccupation institutes, throws out, or hurls forth the subjectile. It makes it speak already, speaks its questions and answers for it, lends it all the figures. And first of all, that of *subjection*, a figure of thought that consists of interrupting the adversary (the one that "betrays" or who could "complain") and supposing his response, predicting what he could say and already making some response to it. The other name of subjection is pre-occupation [*ante-occupation.*] "This figure," says a dictionary, "presents itself often in the form of *dialogism.*"

79. The same text, quoted above by Paule Thévenin, somehow forces the succubus to recognize itself as the agent, the subject of a verb (*succuber*, that we associate, among other things,

with *succumber* as much as with *sucer*, as if the feminine succubus were to vampirize us unto death).* As for the verb *incuber*, Artaud stretches it somehow toward its homonym (he incubuses, the incubus):

The goal of all these figures drawn and colored was an exorcism of malediction, a bodily vituperation against the obligations of spatial form, of perspective, of measure, of balance, of dimension, and, through this vindictive vituperation, a condemnation of the psychic world encrusted like a louse on the physical world that it incubuses or succubuses while claiming to have formed it.

Sucking what is "good," that is *succulent*, "my body," getting a taste for it in their turn, the succubi are acting *underneath*, under the cover but probably also by the cunt. There is a cunt [*cu*] in the word succubus. The search for fecality—in the birthing and under the cover [*couches*]: in bed.

* "Suppôts et suppliciations" associates on the same page the succubus and the vampire: "It's in trying not to be god / that I am day and night inundated with the sea of fucking succubi, / kept in the gaseous placenta of the seminal liquid of the mother-waters . . . it's in trying not to be god that I am honored nightly by the visits of a hundred thousand vampires, etc., / and it's because my body is *good* that it is always visited in such detail" (XIV, 141). These "corporeal suppurations" (ibid.) are as maternal ("mother-ocean," "mother-waters") as they are paternal ("fuck," "seminal liquid.") Perhaps the succubus is more maternal, the fiend paternal, with a subjectile coupling in short the father-mother. This is the "skin" and the paternal "fiend": "It's me, Artaud, Antonin, / fifty years, / who is doing it, / taking the skin and bursting it, / instead of waiting for his physiological reestablishment by a fiend in the sense of the new papa . . ." and right afterward, there come up again the notions of right, skill, awkwardness, punishment, dressage, and co-erection: "just so, in the time of dizziness, / I don't refer to god / in order to have the father's children stand up straight . . ." ("Etat civil," XIV, 32).

80. Will I have been forcing things? Perhaps it will be thought that I have given too much weight to this word the *subjectile* that Artaud uses only three times in all. So I would myself have forced the subjectile. To this suggestion, I have no other answer than this: what I am writing here—which claims to show, on the contrary, a necessity. Neither the absence of forcing on my part, nor of selection, sorting out, chance. But first of all no reading, no interpretation could ever prove its efficacy and its necessity without a certain forcing. *You have to force things.* Then there is the necessity of chance [*le sort*](with all the families of words and meanings that interweave in it, especially with Artaud: *sort, sortilège, sorcier, sortir*)[chance but also spell, sortilege, sorcerer or witch, to leave], and of the spell you know is also cast, and conjured up, as well as the necessity of the *forçage* which forges and perforates. These two necessities are thought out, posed, thematized by Artaud. I have tried to show this just about everywhere, but in particular in the text of February 1947 which we are reading and which names the subjectile. The word *force* appears there five times in one page, speaking of my "terrible réserve de forces" [terrible reserve of strength], my "terrible arsenal de forces" [terrible arsenal of forces], and my "armes forgées" [forged weapons], and "la force où elles puisent c'est moi" [the strength in which they dip is myself], "la force qui ne se voit jamais et qui est corps" [the strength which never sees itself and which is the body]. And then "ce forçage d'où est venu *le premier courant*" [this forcing from which *the first current* came]. At the end of the same text: ". . . the inside that forms the crime . . . the fetus is the fat thing that came out of the hollow underneath . . .".

81. XIV, 129.

82. Among so many other examples, I will choose these, for obvious reasons: the undissociation of the father-mother, the utero-phallic nature of the birth, the search for fecality, the anal expression or expulsion—and the word *forcené*—are gathered in the same spurt of sentence: "The uterine mother-father of an anal unsensing [*forcené*], which, by force of loving in itself its own power of maternality, draws forth a soul from it, which remembers having been eternally loved" (XVIII, 172). Most of the motifs we are dealing with here find themselves drawn into this text, a text of "trance" but "Before the trance there is a meditation of anal incubation . . .". Another example:

Now . . . *that this unavowable army of succubi and incubi armed only with their hatred against anything that remains in me of an unused sentimentality. . . . And thus it is that hell was born. . . . Furthermore the old box of humus excrement will come back when man will have stopped being this lowly weasel scratching his sex as if he*

could make the secret of the daddy *come out of it, out of the mouth of his own* mummy, / *and* daddy-mummy *itself will have made way for man, without hieroglyphics and secret keyboard. / But it will take a lot of blood to make the shit box* healthy, washed, *not with shit, but with love-god. (XIV, 150–151)*

As for the anal expulsion according to Artaud, I refer to Guy Rosolato, "L'Expulsion," *Obliques,* no. 10–11 (December 1976), pp. 41ff.

83. Still in the same text of February 1947: "And the faces I made were spells—that I burned with a match after having just as meticulously drawn them." In one image, you can read: ". . . and I will have them perforated and will burn their marrow . . .".